D1245076

**mneme**

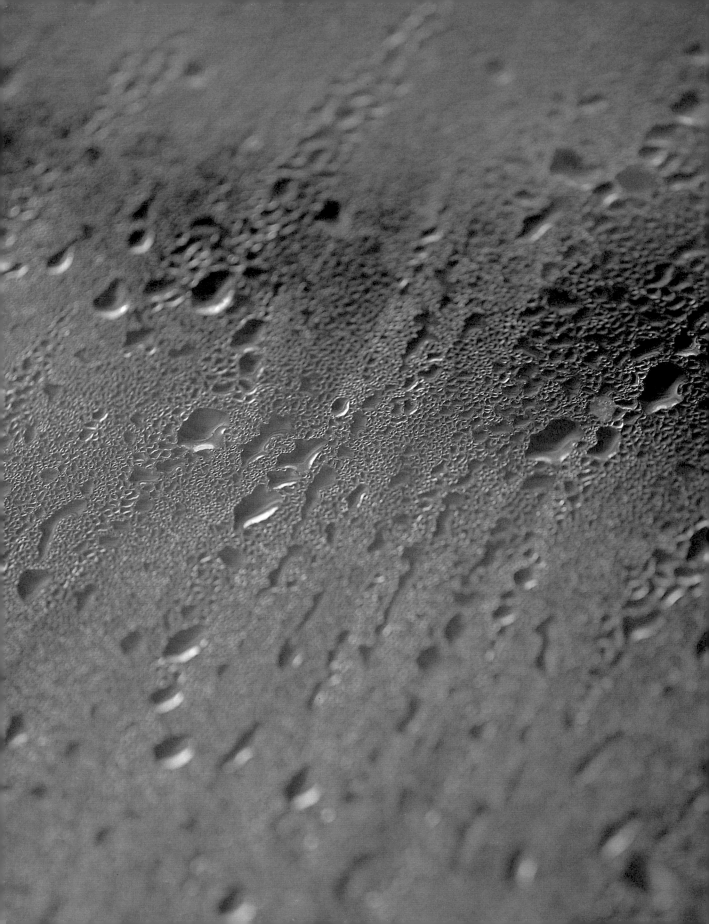

# Ann Hamilton

# mneme

TATE GALLERY LIVERPOOL

# Contents

# Foreword

This publication documents 'mneme', the installation made by Ann Hamilton at Tate Gallery Liverpool in January 1994. Ann had made two previous visits to Liverpool, and the city, its historic docks and daily life, elicited the strong visceral response which is the starting point for her work. We were intrigued by her proposal to link the ground and the top floor of the Gallery's warehouse building, using its spaces in a wholly imaginative way.

It is no coincidence that much of the meaning of Ann Hamilton's work is manifested in the making of it. It is always dependent on the good will and faithful labour of many individuals. 'mneme' was made by a large community of people, most of whom live in Liverpool but some of whom travelled long distances to take part. Janet Hodgson and Colin Fallows at Liverpool John Moores University, and Geoff Molyneaux and Peter Jones at City of Liverpool Community College, invited their students to play a full and invaluable part in making the work. A number of the Supporters of Tate Gallery Liverpool volunteered their time. To all of them we offer our sincere thanks.

The Gallery's invitation to Ann Hamilton to work in Liverpool was made at the suggestion of Judith Nesbitt, Exhibitions Curator. Her close relation with the artist and her involvement with the project were instrumental in its success. We would like to thank Sean Kelly and Christina von Schilling for their assistance at every stage of the project. Robert Rogers and Rebecca des Marais, Alfredo Cristiano and Martin Lloyd deserve particular mention. Our thanks also to The Henry Moore Foundation whose generous support has made the publication of this book possible.

Our warmest thanks go to Ann Hamilton for bringing us to 'mneme' and 'mneme' to us.

Nicholas Serota, Director, Tate Gallery
Lewis Biggs, Curator, Tate Gallery Liverpool

# Ann Hamilton: between words and things

Neville Wakefield

In a passage from a short story written by Jorge Luis Borges he quotes from 'a certain Chinese encyclopaedia' in which it is written that 'animals are divided into: a) belonging to the Emperor, b) embalmed, c) tame, d) sucking pigs, e) sirens, f) fabulous, g) stray dogs, h) included in the present classification, i) frenzied, j) innumerable, k) drawn with a fine camelhair brush, l) et cetera, m) having just broken the water pitcher, n) that from a long way off look like flies'.[1] Within this bestiary of the imagination is hidden a paradox which was to absorb the Argentinean writer throughout his life. Language, for Borges, is a map always in search of a territory. It imposes order, it draws boundaries, classifies and taxonomises and yet remains always an abstraction, separate from the world of lived experience, separate from the very thing that it seeks to describe. The strange encyclopaedia thus derives its powers of enchantment from the fact that what is impossible is not the proximity of the things listed, but the very site upon which such a meeting could take place. Always dissonant, the space of language and that of experience are here rent apart and the system of elements is rendered incomprehensible: the meeting of the animals takes place only in language, in the immaterial sound of the voice enumerating them, or on the page itself. Secretly undermining the very order that it seeks to impose, the Chinese encyclopaedia constitutes an unthinkable space. Revealed by language, its subject nonetheless glimmers far beyond it – denying the very substance that brings it into being.

Ann Hamilton is also concerned with the negotiation and transgression of borders and boundaries, the relationship of language to epistemology and the articulation of the inarticulate. Of the dozen or so major installations that she has produced over the last six years, all have, in some way or another, turned upon the fulcral point that separates what we know from how we know it. Site-specific, impermanent, and subject

to their own internal processes of transformation and decay, Hamilton's beguiling installations are experienced in time and reworked as memory. The experience can be likened to the reading of a short story by Borges. Moving freely through the observed, imagined and remembered, we find the same meticulous attention to the visible surfaces of objects and events, a similar attention to the self-generating force of language. Drawing strength from this predicament of uncertainty, they exist as poetic constructs, leaving the impatient viewer bent only on catharsis and resolution, with little more than a set of random objects and luxuriant surfaces bobbing in an open sea. Meticulously constructed, slow and complex in their unravelling of experience, these grandly orchestrated spaces demand that we shift our perception of the world away from the pairing of irreconcilable opposites – the Plimsoll line dividing difference from similitude, inside and outside – and pay attention instead to how we constitute the Other, at the threshold of nature and awareness. They oblige us to confront the world as if our habitual means of contact need to be relearned.

To this end Hamilton constructs new fields of visibility and sensory awareness notable at first for their material density. On different occasions these installations have included an examining table arranged with 16,000 freshly cleaned teeth, a copper mosaic made up of 750,000 pennies set together in a thin layer of honey, a wedge-shaped form of 800 pressed and laundered men's shirts, floors made of tons of obsolete cold-linotype, sheep's fleece and horsehair, entire rooms covered with minutely detailed exoskeletons of numbered metal tokens, once pristine white spaces endlessly diffused with smudges of candle soot, paprika or algae. Often these strange environments relate to the conditions and histories of the places for which they were made. For the São Paulo installation 'parallel lines',[2] Hamilton accumulated thousands of votive candles of the sort seen in virtually every Catholic church in Brazil. The centrepiece of 'indigo blue', made for the Spoleto festival in Charleston, consisted of tons of blue work uniforms, obliquely referencing an agricultural past and long deceased economy for which indigo had been one

of the main cash crops. In Minneapolis, known colloquially as 'mill city', it was flour that dominated the space; in downtown New York cloth littered the floor, perhaps in silent testimony to the now displaced ragtrade. But these elements, rather than signifying on their own, belong to syntax, the grammar of a room or environment, often watched over by a solitary figure performing a simple repetitive task.

Sometimes an animal as well as a human presence is included: in Pittsburgh canaries flew around an old house while wax sculptures in the form of human heads melted, dripping through to the floors below; in San Francisco the spectator's gaze was met by that of three sheep penned behind bars in a small enclosure at the rear of the room. A variety of natural organic substances – honey, turkey carcasses, sheep fleece, beetles, wild grasses, pig skins and moth lava – have all, one way or another, been given a sculptural presence within these strange rooms. Sounds and smells are introduced, sometimes as animal by-products, at other times recorded, or via the material itself: in Holland the dank earthiness of thousands of bulbs, in Santa Barbara the medicinal scent of eucalyptus. Set against this vast and complex palette is a surprisingly straightforward ambition, simply 'to slow you down enough for you to be able to pay attention differently'.[3]

'tropos', made for the Dia Center for the Arts, New York, during the summer of 1993, elaborates many of the themes sounded in previous works. It invokes an immemorial past through the sleeping memories of the body. Typically you enter this cavernous space with a certain trepidation, aware of the portal as border, a dividing line separating interior from exterior, one passage of experience from another. Stretching before you a seemingly limitless sea of horsehair has been laid across a gently undulating floor. Irregularly patterned as if by the swirls and eddies of a receding tide, the effect is oceanic. Fear of the material vies with a desire for abandonment. Liquidating the 'spectacle complex' within this mass of uniformity, Hamilton shifts attention from analysis towards poetic contemplation. Stubbornly uncommunicative, yet infinitely evocative, the oneiric quality of this great hide lies somewhere between these two poles

of domination and dispersion – somewhere in that mysterious psychological space that Bachelard in his meditations on immensity identified as 'the philosophical category of the daydream'.[4]

Adrift somewhere in the middle of this atavistic ocean, a single figure, simply dressed and silent, is bent over a simple metal desk as if absorbed in the repetition of an endless task. Moving towards this silent custodian of the space you become aware of other elements contributing to the uncanniness of the experience. Subtle tinkering with the architectural fabric of the building, the remaking of the floor to a gentle gradient and the substitution of translucent for transparent glass in the windows heighten one's awareness of the interior space. From outside come the intermittent sounds of a voice – plangent and hesitant as if struggling with the very stuff of language. A faint smell of burning hangs in the air. Approaching the figure you identify the source of the smell. In front of her is a book, and as each line is read it is singed out of existence with a small heated implement, language and text disappearing in a thin arabesque of smoke – the delicate imprint of the erased text, a palimpsest of language and the body. The atmosphere is sybelline – as if you had stumbled across the ritual of an archaic culture. Rich in memory and evocation, the experience ends up being intensely private, an interior discourse or private meditation on the inadequacy of communication and the frailty of language.

'tropos', the title of this piece, is derived from the biological term 'tropism' used to describe an organism's internal response to external stimuli, such as a plant's tendency to grow towards light. It is also suggestive of the way that we respond to all of Hamilton's work. Seeking the co-operation of the senses in which thought and feeling are conjoined, she draws upon available resources to form complex non-linear poetic patterns, intermingling the concrete with the abstract, thought with feeling, real and imaginary, specific and universal in an effort to stimulate some kind of 'tropistic' response. Inclined towards the sensory and the intuitive, the accumulation of sensations involves a quiet persuasion not just of the eyes but of the entire body. The effect of the experience is akin to

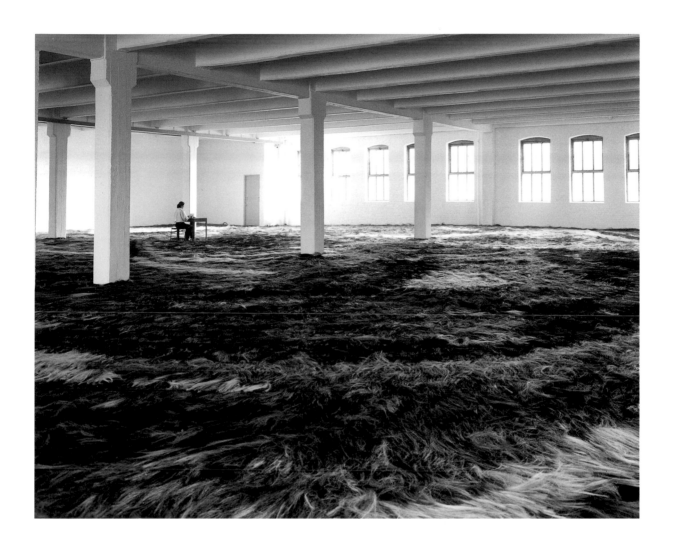

'tropos',
Dia Center for the Arts,
New York, 1993

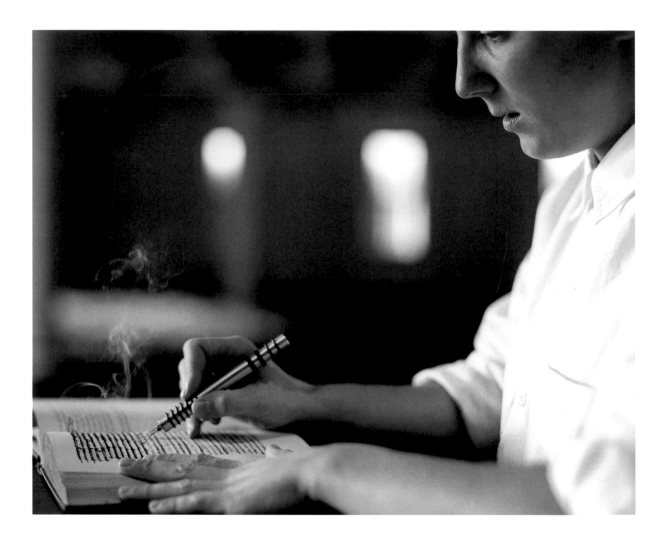

'tropos', detail

the way in which we are aware of changes in barometric pressure – changes we can feel without necessarily being able to describe.

Appeals to what Hamilton refers to as the wisdom of the body often take the form of destabilising the traditionally passive relationship between art object and spectator. Walking around these installations becomes a question of negotiating a physical as well as psychological passage through the various elements. Impeded by tufts of hair, the surface irregularities of cold-type, the uncomfortable crackling of pig skins, the hollow reverberations of sheet metal or the brittle fragility of glass, one's tread is tentative and habitualities of posture and deportment are interrupted. Here, the body itself becomes implicated in the uncomfortable dramas going on beneath the surface – dramas that seem to play out the incommensurability between immediate physical sensation and abstract knowledge of mind and matter.

Arresting experience before it has had the chance to settle into the sedimentary categories of the ordered intellect, Hamilton taps into areas of bodily and biological memory existing prior to or beyond cognition. It is this largely uncharted territory preceding the ordered rationale of consciousness that is the subject of Elaine Scarry's book *The Body in Pain*. In a relevant passage she relates a young girl's ability to recall a piano song as an example of the persistence of bodily memory over time:[5]

> So too her fingers placed down on the piano keys may recover a lost song that was not available to her auditory memory and seemed to come into being in her fingertips themselves, coming out of them after the first two or three faltering notes with ease, as though it were another form of breathing.

Triggering biological memories that in some way by-pass normal thought processes, this form of recollection relates less to the abstract time of mental processes than to the endogenous rhythms of the body itself. Marking, as well as sensitising us to the passage of this bodily time, are the solitary figures in Hamilton's work, silent custodians of symbolic space. These figures, often performing a single repetitive action (sometimes a distillation of the cumulative gestures performed during the

preparatory labour) by their withdrawal from the community of speech and their unhurried metronomic gestures, draw attention to the internal cyclical time of the body, its subterranean memories and non-cognitive powers of recollection.

Underpinning all of Hamilton's painstakingly constructed environments is an interest in natural systems and patterns of growth and accretion. In the process of coaxing the work into an image of accumulation, nothing escapes the mark of the human hand. Preceding and written into our experience of the work is an ecology of labour, manifest and resonant in the surfaces themselves, as is the collective endeavour that brought them into being. The tasks involved are often compulsive and repetitive, mimicking perhaps the Sisyphean nature of domestic labour – the ironing and pressing of hundreds of men's shirts; the coating of the walls with pond algae, beeswax or paprika; the sewing together of innumerable strands of horsehair – the endless reiteration of a single object to produce an organic whole.

An undergraduate student of textile design at the University of Kansas during the 1970s, Hamilton sees her current work as extending out of an understanding of fabrication, as well as the sense in which clothing takes on the sentient qualities of skin. And it is the tactile and sensory qualities implicit in cloth that often find their way into the surfaces of the installations. As she points out, 'much of the sensibility and process of what I do is still indebted to a background in weaving, in cloth and its intrinsic metaphors. Cloth, like human skin, is a membrane that divides an interior from an exterior. It both reveals and conceals. It can surround or divide. In its making, individual threads of warp are crossed successively by individual threads of weft. Thus, cloth is an accumulation of many gestures of crossing which, like my gestures of accumulation, retain an individual character while accreting to become something else'. Performing a sort of metamorphosis by accumulation, Hamilton's material alchemy transforms individual objects – be they men's shirts, metal tokens, pennies or strands of horsehair – into 'living' tissues, frail boundary layers which bind the site into tentative unity.

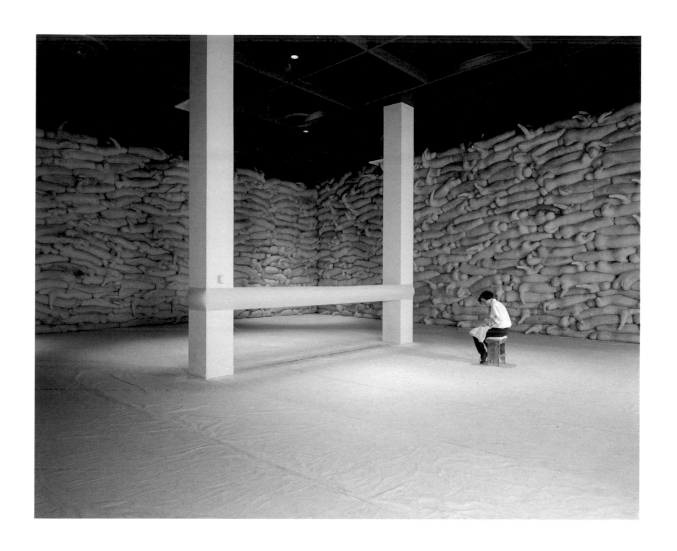

'a round',
Power Plant,
Toronto, 1993

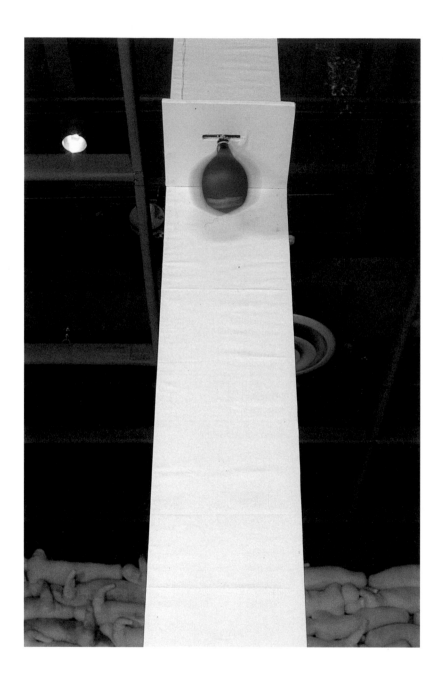

'a round', detail

Where fabric has been given an explicit presence, as in the vast mounds of clothing of both 'still life' and 'indigo blue', it has been used to memorialise and honour absence of the human body – the form of which is provided and denied as each article is cyclically worn and tended. A similar reciprocity, this time pivoting on the relationship of making to unmaking is replayed in 'dominion' and more recently in an installation in Toronto, titled 'a round'. Made for the Power Plant gallery, a waterfront space once serving the storage facilities that lined the old docks, the neatly stacked sawdust-stuffed wrestling dummies lining the space seemed to evoke the dock's past as site of transition and accumulation. The dummies with embryonic heads and vestigial arms suggested that this was a holding bay for human forms. Underfoot, a canvas-lined floor transformed the space into a silent interior, womb-like and insulated from the outside world. Dominating the central space were two pillars, also clad in canvas. Stretched taut as if across the sounding box of some gargantuan instrument, a seemingly endless length of yarn formed a wide horizontal band. Above this were two mechanised leather punch bags, periodically shattering the stillness of the room with a clatter of activity. Trailing off from this central spool a single thread formed an umbilical link between a seated figure and mass of yarn. As she knitted, so the thread was unwound.

Within this cavernous space differing dramas of the human hand and body were enacted. Overhead the punch bags proposed an invisible, perhaps masculine presence. The periodic flurries of activity invoked the rituals of boxing, suggesting, as they do, a violent choreography of hand and body, naturalised in training and realised in the fight. Implicated in the two dramas taking place within the room, the spectator became both witness and participant. A death-like stillness both pacified and threatened. Poised as if on the brink of decisive action, the opposition of stillness and activity, of creation and destruction, formed an uneasy alliance in which the suspended 'spectacular' time of the boxing was counterpoised against the 'biological' time of the woman's hands, as she continued to knit to transform the single thread into a cohesive, wearable

whole. Progressively unwinding the yarn from around the two columns, the central division of space was unmade in order that it could be remade to the scale of the human body.

As well as providing the structural model behind these meticulously worked and interwoven surfaces, fabric is also a form of skin, an epidermal layer both connected and extraneous, boundary layer dividing inside from outside, nature from culture. Sensitising these borders has long since been one of Hamilton's key ambitions. For her first performance at the Franklin Furnace, New York, in 1984, Hamilton wore a suit composed of toothpicks, literalising what she has termed 'the articulation of the self at the boundaries of the body'. Here the tactility of the skin was suggested as touch was refuted. Just as the skin represents the perceptual edge of the body, so Hamilton's carefully tended linings act as membranes to the outside world. Binding the site into a unified whole, these skins provide the continuity of an enclosing fabric. Sometimes this is referenced as a literal presence, as in the pig skins of 'passion', the vast hide of 'tropos', or the concealed fleece of 'between taxonomy and communion', but more often than not it is metaphorical – the soot-licked walls of 'parallel lines', the hospital blankets insulating the walls of 'linings' or the watermark of algae in 'the capacity of absorption' – they are surfaces that assert the space as container or somatic interior, thereby implicating the viewer within.

'In normal contexts', writes Elaine Scarry, 'the room, the simplest form of shelter, expresses the most benign potential of human life. It is, on the one hand, an enlargement of the body: it keeps warm and safe the individual it houses in the same way the body encloses and protects the individual within; like the body its walls put boundaries around the self preventing undifferentiated contact with the world yet in its windows and doors, crude versions of the senses, it enables the self to move into that world and allows that world to enter'.[6] Both magnification of the body and miniaturisation of the world, Hamilton's 'rooms' elaborate this paradox of the body as being both container and contained. Offering a discourse of limit (played out around what Lacan has termed the 'eroto-

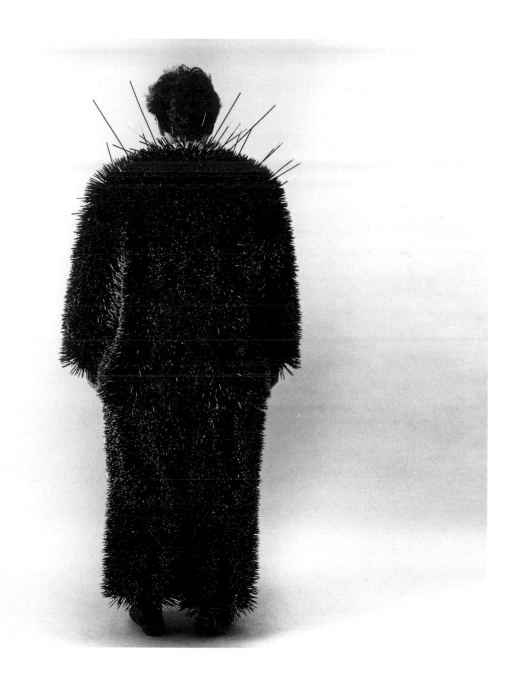

'suitably positioned',
Franklin Furnace,
New York, 1984

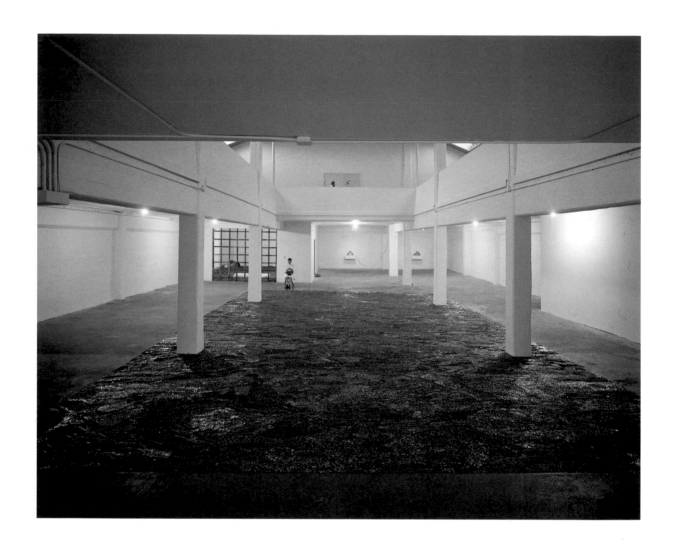

'privation and excesses'
Capp Street Project
San Francisco, 1989

genic' zones of the body – the gaps or cuts in the enveloping shroud of the skin and the negative interior spaces of the ears or mouth) Hamilton calls attention to the room as both site of polymorphous eroticism, the undifferentiated experience of materiality, and revulsive differentiation.

Much of her work's associative and visceral power feeds on this sort of ambivalence. In a 1989 piece titled 'privation and excesses' made for the Capp Street Project in San Francisco, Hamilton converted the $7500 grant into pennies, laying them on the floor in a thin coating of honey to form a vast expanse of copper mosaic. Here, as she put it, 'the money becomes a substance, creating a skin on the existing architecture. Like skin and like money, they function simultaneously to protect, conceal and reveal'.[7] Behind this shimmering but valueless field, a seated figure was obsessively ringing her hands in a felt hat full of honey. The action, later echoed in the hand-washing of 'passion', was suggestive of the sort of exaggerated behavioural traits described by Judith Rapoport in her book on the experience and treatment of obsessive compulsive disorder. Tyrannised by doubt, the obsessive-compulsive's life is dominated by senseless repetition and ritual. Normal daily procedures such as washing – normally associated with the socialising aspects of animal grooming patterns, good health, kinship acceptability, rites of purity and group ritual to protect against danger – become the sole line of defence against the nightmare of contamination. Significantly it is the permeability of the skin which is the focus for so much of the anxiety of the boy who could not stop washing (the title subject of the book) and it is the viscosity and stickiness of honey that presented the greatest phobic threat: 'Stickiness', Sartre said, 'is halfway between solid and liquid. It is soft yielding, and a trap. It clings like a leech and attacks the boundaries between oneself and it. Columns of stickiness falling from my hand, he said, suggest my own substance is flowing into a pool of stickiness'.[8] Violating the boundary between inside and outside, the honey threatens to turn the entire skin into a permeable border, which like the mouth becomes an indeterminate space, both source of pleasure and site of phobia and taboo.

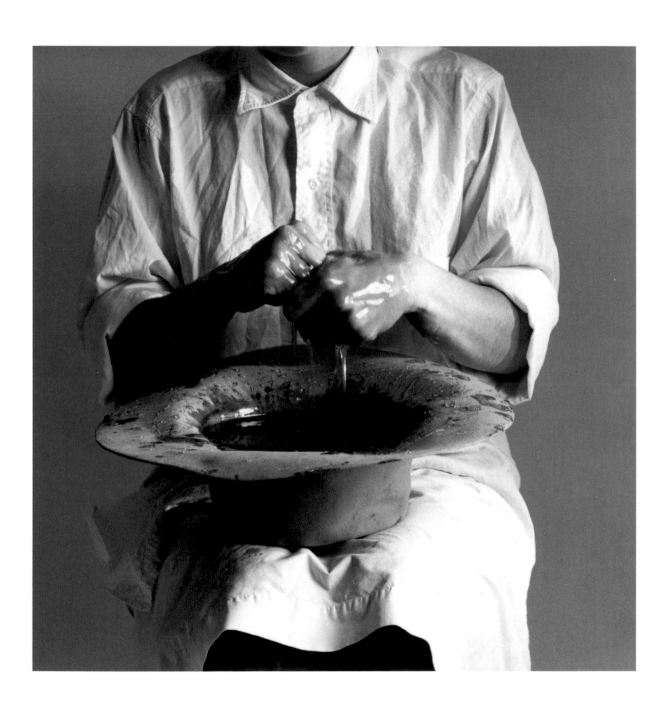

'privation and excesses', detail

Language originates from the mouth. It comes from within, obeying the speed of the body, the dexterity of hand and the formation of the palette. But whereas the voice, the organic form of language, has the power to connect bodies at the site of their juncture with the outside world – ears and mouths – language as an abstract and totalising system enacts a kind of conceptual violence apart from the body. Far from being the primary grid of things, the nominalist fantasy, language is revealed as a historical construct coherent only with the density of its own past. Archaeologising this past, Hamilton's spare and pregnant spaces excavate the pre-history of communication offered as the passage of meaning from one body to another. At one level they confound the easy assignation of meaning to things, the density of material and wealth of detail being continually re-absorbed by the silence of the objects themselves. At the same time however, the obliterated texts – whether erased with saliva from the mouth or singed out of existence with the same practised movements of the hands that brought them into being – seem to return language to the body, demanding not that we abandon it altogether, but rather that we reconsider the social space of understanding. Meditating on the point at which language dissects space, we find that our attention is moved away from the concrete materiality of the written word and returned to the evanescence of speech. The shift is significant. For, as Susan Stewart tellingly points out:[9]

'Speech leaves no mark in space: like gesture it exists in its immediate context and can reappear only in another's voice, another's body, even if that other is the same speaker transformed by history. But writing contaminates, writing leaves its trace, a trace beyond the life of the body. Thus while speech gains authenticity, writing promises immortality, or at least the immortality of the material world in contrast to the mortality of the body'.

A sense of mortality and of the proximity of death is present in all of Hamilton's work. Sometimes it takes the form of a thinly veiled erotic, linked perhaps to the material liquifaction of space and the experience of the body prior to birth. More often it takes the form of an imper-

manance inherent in the work, as it becomes subject to natural systems of transformation and reciprocity and the inevitable process of organic decay. Panes of glass crack underfoot, immaculately laid tresses of horse-hair become ruffled and tangled, vegetable matter begins to rot, soya beans sprout, larvae pupate, snails demolish brain-like cabbages, colonies of dermestid beetles steadily strip the flesh off turkey carcasses. Actualising the passage of time within the work, Hamilton contemplates decay as a metaphor for the irrevocable distance between memory and experience. Invited to participate in the evocation of this impossible space – the space between the abstract order of language and the material substance of a world that glimmers far beyond it – we find ourselves asked to return consciousness to the body, its inscribed histories and ultimate mortality. The ordered opulence and sumptuous materiality which may act as the initial pull is also a decoy, drawing the spectator into a deeply stimulating but darker and more ambivalent world.

1.  Within an essay by Borges on 'The Analytical Language of John Wilkins', in *Other Inquisitions 1937–52*, first published in translation 1964, reprinted by the University of Texas, Austin Press, Austin, Texas, 1993, pp103–6.

2.  All works by Ann Hamilton referred to in the text are listed in the biography on p105.

3.  This, and all subsequent quotations, are drawn from conversations with the artist conducted during the installation of 'tropos' at Dia Center for the Arts, New York, September 1993.

4.  Both this and the 'spectacle complex' are discussed in Gaston Bachelard's *The Poetics of Space*, Boston, 1969, reprinted 1994, p183,190. Bachelard writes about the 'spectacle complex in which pride of seeing is the core of the consciousness of a being in contemplation... I should like to liquidate, as it were, the spectacle complex, which could harden certain values of poetic contemplation'.

5.  Elaine Scarry, *The Body in Pain: The Making and Unmaking of the World*, New York and Oxford, 1985, p109.

6.  Elaine Scarry, ibid, p38. The whole section 'The Objectification of the Prisoner's World Dissolution', pp38-59, is pertinent to Ann Hamilton's work.

7.  Quoted in Margo Shermeta, 'Ann Hamilton: Installations of Opulence and Order', *Fiberarts*, vol 18, no 2, September/October 1991, p32.

8.  Judith Rapoport, *The Boy who couldn't stop Washing*, London, 1989, p92.

9.  Susan Stewart, *On Longing*, Durham and London, 1993, p31.

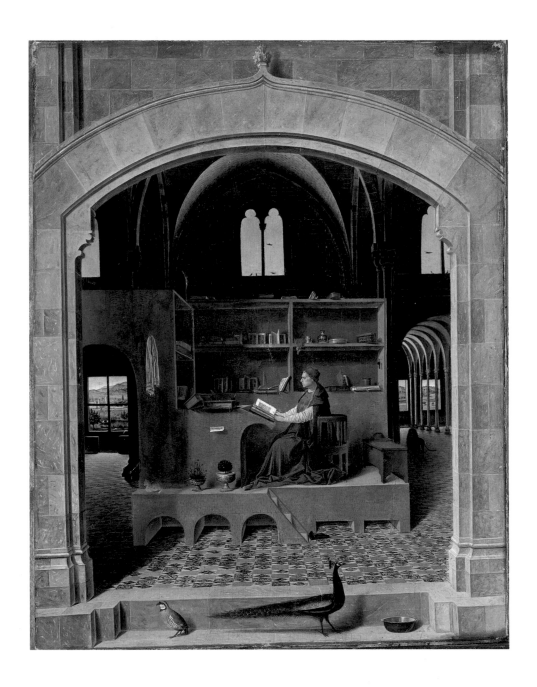

Antonello da Messina,
'St Jerome in his Study', 1475/6

# On entering 'mneme'

Judith Nesbitt

To begin with, a picture. A painting of St Jerome in his study, by the Italian Antonello da Messina, a supreme example of the mimetic skills of the artist achieved in both northern and southern Europe in the period we call the Renaissance. St Jerome, dressed in cardinal's robes, is seen through a window, at work in his purpose-built study set oddly into the lofty ecclesiastical space. Our position outside this scene is established by our closeness to the birds and brass bowl within grasp on the window-ledge. From here we can measure the immense architectural space by following the perspectival recession of the ceramic floor tiles. The pastoral landscape beyond, in which people walk, ride horses, and row boats on the river, is a purposeful contrast to the interior world of mind and spirit. The picture is a complex arrangement of screens, archways and openings – calculated apertures through which we focus on the saint at his study.

Antonello's small painted canvas, a 'cabinet picture' intended for close observation and prolonged consideration, provides a useful focus in considering Ann Hamilton's most recent installation work. The painting is, above all else, a triumph of illusionism, a textbook demonstration of the Renaissance 'window onto the world' – of both culture and nature. Alberti, artist and writer of a treatise on painting, devised a formula for picture-making which began with the 'I' of the artist:[1]

> First of all, on the surface on which I am going to paint, I draw a rectangle of whatever size I want, which I regard as an open window through which the subject to be painted is seen; and I decide how large I wish the human figures in the painting to be.

Alberti's practical (and philosophical) model of a rectangular grid which frames and measures the world of vision establishes a secure and priviliged position for the viewer, who assumes the role of artist, fixing (through his act of looking) the fleeting, perceptual world. So powerful is

Antonello's vision of hermetic concentration that it seems as if an untimely sneeze would rupture it and rob us of our pleasure. Stillness is a condition of our being there.

This picture is a model of the web of relations enacted when we look at pictures. It is a model which Ann Hamilton's work dismantles, in an equally complex act, with all the dexterity and grace of bomb defusal – quietly and in her own time. In Antonello's picture, space is represented as something which can be known and mastered. It is measured by perspectival recession, by the mathematical rhythm of the arches, and the consummate transition between the interior and exterior world; space is subject to the mastery of the artist's eye and hand, as he stands outside the scene, picturing and (by extension) controlling it. Hamilton proposes another model of seeing and knowing, a mode of picturing which is much less susceptible to the logic of diagrams. Hers is an invitation to enter an unframed image of the world – a space not of fixity but of fluidity, an unbounded, inverted, perceptual field in which sight is no more important than any other sense, a space in which the trap-doors of knowledge and memory are off their hinges, and in and through which we are invited to picture ourselves. When the viewer is acknowledged, and a space prepared for them within the work of art, the effect is one of welcoming embrace. Instead of being the observer – standing still outside Antonello's window – we are the subject, in the following sense, explained by Rosalind Krauss: 'we feel ourselves to be the origin of the coordinates of perception. [To be the subject in this sense] is to experience one's toehold on the world as continually reconstructing one's place at the intersection between the vertical of one's body and the horizontal ground on which one stands. Through all the displacements of one's moving body, this toehold remains firm, because one carries the perceptual coordinates around with one; they are the baggage of one's subjective coherance, one's fixity. I stand fast; therefore I am'.[2] Hamilton's inclusive art has no prescribed viewing position, but many are available to us. This reflexive position is integral to the making and experience of her work, as also in writing on it – the author needs to move within the

installation. And it is in this activity of response that her work offers up its meaning.

\* \* \*

The first thing, in the antechamber, is a traditional museum display case: a monument to the rationality of the nineteenth century mind, which systematised and categorised knowledge into a box. Its sombre bulk stops us in our path, forbidding, and bidding our attention. It establishes symmetry like the rules of the house, inviting us to pay our respects. Taking a sneaking peep to see what lies within this box for learning (those books of Jerome's, perhaps, or were they Antonello's?) our act of looking is frustrated, for the panes of glass are fogged with condensation. There is an inescapable bodily reference in the sarcophagus-sized case, room enough for any body: a case with spine and shoulders, inviting us to lean upon it. The panes of glass are warm to the touch, so the heat of our hands leaves little trace of our fingers. Like warm moist air breathed onto a window pane, momentarily erasing the world, the condensation makes the transparent surface visible.

Beyond the case hangs a curtain. Beyond this curtain is another, and another, layered veil upon veil, so that in order to pass through, we have to part the curtains with our hands in an act of opening which is never concluded. Metaphors of disclosure come readily to mind, or hand: the domestic allusion to curtains (in England, as Ann Hamilton noted, often three layers deep, with curtain, lining and netting) which screen private life from public view; the sexual reference to being 'between the sheets', invoked as much by the intimacy of the pockets of space (wide enough just to envelope the body) as by the disarming frankness of coming suddenly into close proximity to another person in that space; then also the other-worldliness of a priest's vestments and the solemnity of church cloths and hangings; more sobering still, the enfolding shrouds of death.

Sound is progressively muffled, and there is a gradual but perceptible 'warming' of the layers which absorb the ambient noise of the chamber, and hush our own murmerings, stifling our impulse to speak. As human

sound is drowned, our sense of hearing becomes focused on the quiet-
ness, on the strange seduction of it. Sight is similarly limited to what is
right in front of our nose and to the sides – until we bend down to peep
under the skirts, as it were, at the expanse there revealed. The sturdy
bases of six iron columns (and perhaps the feet of other people) are
glimpsed below, offering a visual measurement of space that disorientates
above. For all the immense, suffocating weight of suspended fabric, there
lies beneath it a landscape of visible space, an opening onto horizons.
Three passages, cut like discrete slits in the skin, permit us to pass
through so much fullness to an empty space where (we might imagine) in
a church, the altar would be.

Retracing our steps to the antechamber, emerging from the folds of
cloth, and passing again the museum case, we come to the industrial
metal box which is the goods lift of a converted nineteenth century ware-
house building. With a double concertina gate constituting two side
walls, the noise as they clank shut is as certain as our apprehension of
what comes next. Through a peep-hole, the darkness of the building
passes by until, slowly transported through four floors from the ground
to the top of the building, we arrive and catch our first glimpse of day-
light. Space, which downstairs was concealed, is now revealed as the lift
doors open onto an empty expanse of warehouse. Rows of windows
punctuate the brick walls, opening the interior to the outside world: on
one side the city, on the other the river. We hear a disembodied voice
and through an arch see its source: a man continuously turning a record
by hand, its sound amplified by the old box record player, set on a
wooden table in front of him. At first raw and indistinct, the voice, as we
attune ourselves to hear it, has a tense, clinical tone, and could be five
decades dead, brought to uncertain life – by turns wavering and crisp. It
pronounces, in sequence, 'the eight cardinal vowels, short and long'
which, as they reverberate through the space, sound as much like the
bleating and baying of an animal (or a human imitating an animal) as the
learned enunciations of a scholar of phonetics.

\*    \*    \*

'mneme' is the title given by Hamilton to this installation. Derived from the Greek word for memory, it refers to the capacity of living organisms or substances to retain the after-effects of experience or sensations undergone by them or their progenitors. Hamilton has long been concerned with the intelligence of the senses: knowledge gained, processed and held within the body. It is an exploration of consciousness itself, an unashamed fascination to know, as a child will wonder, whether our very self – our memory and perhaps what some call the soul – is really formed and held within the brain.

Neurologists now contest the model which proposes that our consciousness is wrought through the brain's functioning as a kind of reasoning machine. They are challenging the orthodoxy that our intelligence is defined in terms of language – that without language there is no thought, and no memory. A recent study of synaesthesia by Richard E Cytowic, *The Man Who Tasted Shapes*, refutes the idea that there is no knowledge that is not intellectualised in its filtration through the body. Cytowic pictures the neocortical computer 'cranking out reasoning', while 'the emotional brain stays behind the curtain pulling the levers. Your inner knowledge behind the curtain is largely inaccessible to introspective language, which means that what you feel about something is often more valid than what you think or say about it'.[3] Such investigations are germane to Hamilton's work, which brings to the surface the inchoate stuff of sensation, memory and imagination.

The passage of spaces within 'mneme', from the antechamber to the fabric-filled chamber, the lift and the 'attic', function as an architectonic passage of memory. In this house of memory there is a fluid movement between past, present and future. Outside the building, the River Mersey, with its huge tidal range, rises and falls as do the surges of memory and the cadence of the human voice.

\* \* \*

Writing in retrospect, the practical workings of 'mneme' are worth a curatorial note, for the work had its own internal rhythm – both in its

making and in its public life. The solitary continually gave way to the social. Visitors were informed by gallery staff that the lift would leave for the top floor every quarter of an hour; the same interval pertained on the top floor for the return journey. This had the effect of creating a loose community of individuals for the duration of the experience. Having been plunged into the intimacy of the curtained space, they then had to share the psychologically awkward space of a lift – in this case, a room-sized goods lift. On the top floor (amid 1300m²) they had the freedom to roam apart, putting visible distance between themselves and others. Naturally these decisions turned upon people's response to the human presence within the work: whether, as often children did, to stand unembarrassedly close to the attendant, to become absorbed in his absorption, or to circle and survey from a distance, often going to the edges of the space, using the windows as an alternative focus of attention.

Staring through the frame of the arched doorway which punctuates the space, my own reverie assisted by the rapt concentration of the attendant's ritual action, I thought of Saint Jerome, fixed in the centre of that picture of Antonello's, absorbed in holy concentration. There he was in my mind's eye, anchored to his table by the gravity of his expression. I saw his books set on the desk, on the shelves, on top of the shelves, propped open and marked at a particular page, his solitude a necessary condition for meditation on the word. But why Jerome? Antonello's red-robed saint had taken up residence with me in this space.

Jerome's life was spent in words, in making fine distinctions and correspondences between words; he was a scholar of Greek and Hebrew, a celebrated translator, most notably of the Bible into common Latin, the 'Vulgate'. He described the act of translation as 'taking meaning hostage', re-phrased by George Steiner in his now classic study of the poetics of translation *After Babel* as, 'meaning brought home again by the captor'. The central tenet of this book is that every act of reading a text from the past, every act of hearing (even in our own language) is an act of translation. Disjunctions of time, context, and experience make these common acts of communication an effort of will to bring meaning home.

Jerome was not alone among translators, however, in acknowledging its limits: some things cannot be translated. Steiner elaborates: 'There are mysteries which can only be transcribed, which it would be sacrilegious and radically inaccurate to transpose or paraphrase. In such cases it is best to preserve the incomprehensible: "Alioquin et multa alia quae ineffabilia sunt, et humanus animus capere non potest, hac licentia delebuntur", says Jerome when translating Ezekial. Not everything can be translated now'.[4] Even a verbal account of immediate personal experience is an act of translation which, as Ann Hamilton's work testifies, can serve to demonstrate the limits of language.

Hamilton's work invokes language even as it seems to deny it, however. Her installations have a sequential structure (often through a passage of rooms), unfolding in time as does a narrative, sometimes with density and complexity, latterly within a more tightly contained structure, like a poem, concentrated and spare. In their semantics, their dextrous play of metaphors, they invite literary comparison. And, ironically for work which relies on the senses to stimulate response, they often have the effect of making people want to recount their experience: each pilgrim has their progress to tell. A further irony for such temporary, site-specific art is that it can be as much talked about as seen; Hamilton's installations have an after-life in memory which is carried and transmitted to those who have not seen them first-hand.

Often the experience itself, however, is one of discomfort and disorientation. The viewer is bereft of customary reassurances for, most disconcertingly, the subject is nowhere to be seen. There is invariably no conclusion, rather a rhythm of unending ritual. It is an experience of being lost in a material dream – a psychological state, of being (as we might say) 'lost for words'. For part of the loss of control that Hamilton's work engenders is a loss of the control that we exert through language. In 'mneme' this unending rite of passage takes place in the dream-like space between consciousness and language: on the threshold of speech.

The cardinal vowels are the hinge sounds of language, a set of eight tongue configurations, not aligned with the vowels of any particular lan-

guage, but the matrix and reference points of all speech: 'a set of systematically established, language independent, universal reference vowels'.[5] They are formed in the extremities of the tongue's position in the mouth cavity. To pronounce them properly, the tongue is thrust far forward, pulled back, or pushed up as far as possible. Actual speech, with its commanding power to order and systematise the world of thought and experience, is dependent on the movements of this dextrous muscle. In 'mneme' the original act of sound-making is unseen – neither the tongue, nor the mouth, nor the exaggerated expression of the speaker's face. But the movements of the tongue (which we hear) are synchronised with the movements of the finger (which we see). The finger thus becomes a surrogate tongue, an instrument for tracing and thereby re-creating the sound of the voice, engraved within the disc. The closer we approach the man and machine the more keenly we feel the intimacy and delicacy of the action. In an act of co-dependency, the machine becomes an extension of the body: conjoined in rhythmic rotation, the arm and needle of the machine trace the 'imprint' of the human voice. What we witness is a model of intimacy, a relation of reciprocity, of call and response, sound and gesture. Its temporality lends an added poignancy: the continual activation of the voice by the hand has the effect of gradually erasing its sound. This is seen and heard to happen as the voice periodically sinks into silence, just as the print of the label becomes worn and erased by the finger.

The heightened attention in 'mneme' to the sense of touch (the most primal of the senses) conjoined with the voice (the most refined instrument of the human body) suggests the idea of a sixth sense, which in another context Bachelard has intriguingly described as: 'this sixth sense that seeks to model and modulate the voice. This delicate little Aeolian harp that nature has set at the entrance to our breathing is really a sixth sense, which followed and surpassed the others. It quivers at the merest movement of metaphor; it permits human thought to sing'.[6]

What then of Jerome, the solitary scholar, pen at hand? This image of the saint, separated from the world and from his companions, in the

translatory act of study, disguises some of the known facts of Jerome's life. Many of his written works were dictated and transcribed. In his *Preface to Solomon's Books*, he thanks Bishop Chromatius of Aquileia for help in financing his employment of stenographers and copyists, complaining that the weakness of his eyes and the frailty of his whole body prevented him writing in his own hand.[7] Jerome's greatest works were dictated, received by the ear of a scribe, and transcribed onto the page. This sets up a very different image – of the mutual dependency of the speaker on the scribe, and the hand of the scribe on the voice of the speaker. Moreover, Jerome's biographer, J N D Kelly, details the scholar's complaint in a letter that he had not been able to correct dictated material since, due to his infirmity, he could use 'only his ears and his tongue for his work'.[8] The communicative act can then be seen as a motion of reciprocity; it is this that we encounter in Hamilton's scenario. 'mneme' embodies a mutuality of the senses, and in its communicative act – the hearing and receiving – offers up meaning for us to grasp.

George Steiner in his book *Real Presences* develops the idea of reciprocity between the listener or viewer of a work of art. The act of reception, he argues, is a sacred trust:[9]

> Face to face with the presence of offered meaning which we call a text (or a painting or a symphony), we seek to hear its language. As we would that of the elect stranger coming towards us... The presence before us may be that of a mute (Beckett urges us towards that grim gest), of a madman uttering gibberish or, more disturbingly, of an intensely communicative persona whose idiom – linguistic, stylistic, hermetically-grounded – we simply cannot grasp. There are literary, artistic, musical works which remain closed or only superficially accessible to even the most welcoming of perceptions. In short, the movement towards reception and apprehension does embody an initial, fundamental act of trust.

In 'mneme' this act of trust is begun in the process of making and experienced on entering the work, when assumed relationships between viewer and object are overturned. The immediate encounter with the empty display case, fogged with the nothingness of breath, leads into the

disorientation of a space shrunk to the few inches in front of our nose, a space which is all soft edges with no concrete space except that evacuated space – like an interval – in which we stand, wondering where it places us. Our apprehension (or unknowing) is contained in the box of the lift, as the breath in the showcase below. But on the top floor, where the elements of breath and touch are conjoined, as in the union of voice and hand, disorientation subsides. In this space, we are given 'the run of the house', a decisive act of trust between artist and subject. For we are now no longer 'viewer' or 'listener', but the very subject of the work, whose agent is the human presence. This ritual act of concentration is an invitation to draw close to meaning. Or as Steiner would have it: 'We know and do not know. We bend closer to the speaker as to a guest or traveller whose voice tires. A rich undecidability draws us. This is, to be sure, the poet's design'.[10]

However unavailable to language is our experience, in our comings and goings within the space, we feel our bodies as a wellspring of remembrance, of what is and was and will be. The writer Robert Graves described memory of the future as being what we call instinct in animals and intuition in humans. In 'mneme' the communicative act is an intuitive act, and an act of reciprocity, of coming home to ourselves.

1.  Leon Battista Alberti, *On Painting and Sculpture*, ed and trans Cecil Grayson, London, 1972, p67. See also Svetlana Alpers' discussion of Alberti's model in *The Art of Describing: Dutch Art in the Seventeenth Century*, London, 1993, chapter 2.

2.  Rosalind Krauss, *The Optical Unconscious*, Cambridge, Massachusetts, 1993, p183.

3.  Richard E Cytowic, 'What shape is that taste?', *Independent on Sunday*, 13 February 1994, Review Section, p54.

4.  George Steiner, *After Babel*, Oxford, 1975, second edition, 1992, p262.

5.  J C Catford, *A Practical Introduction to Phonetics*, Oxford, 1988, p221.

6.  Gaston Bachelard, *The Poetics of Space*, Boston, 1964, reprinted 1994, p197.

7.  J N D Kelly, *Jerome: His Life, Writings and Controversies*, London, 1975, pp141-2.

8.  J N D Kelly, ibid, p79.

9.  George Steiner, *Real Presences*, 1989, reprinted 1991, p156.

10. George Steiner, ibid, p162.

# mneme

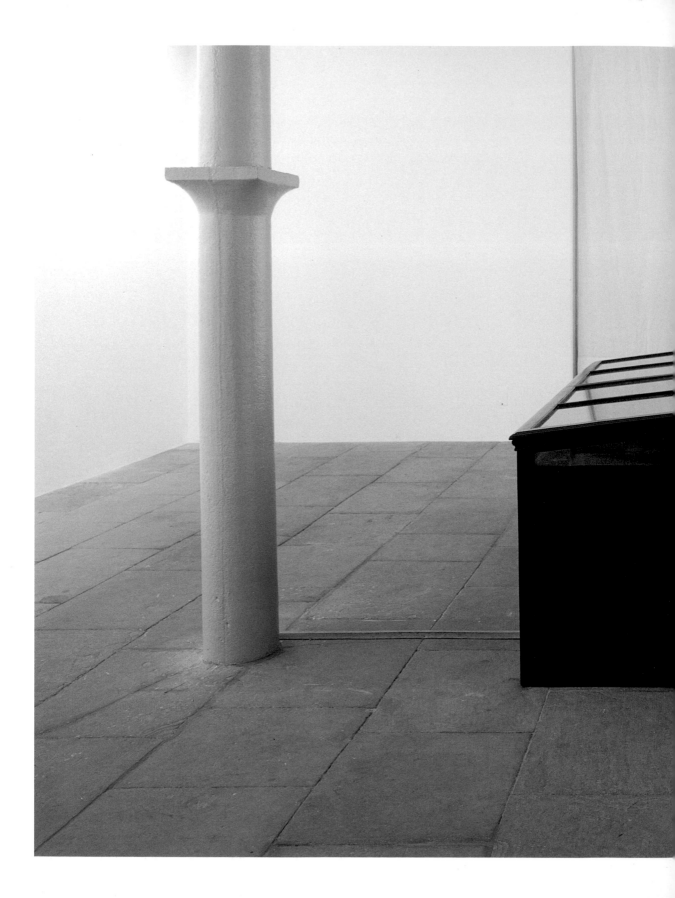

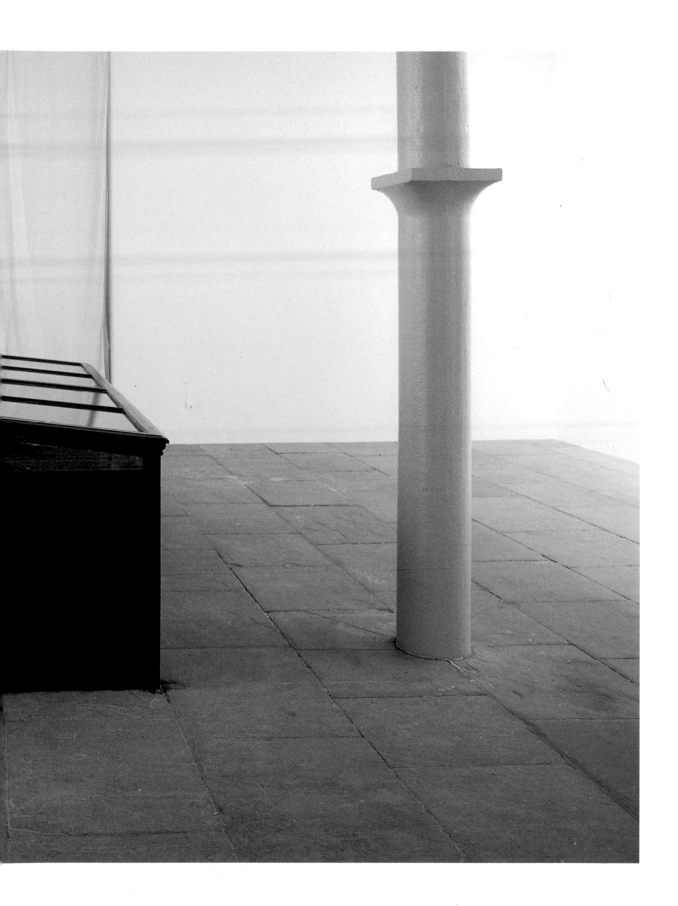

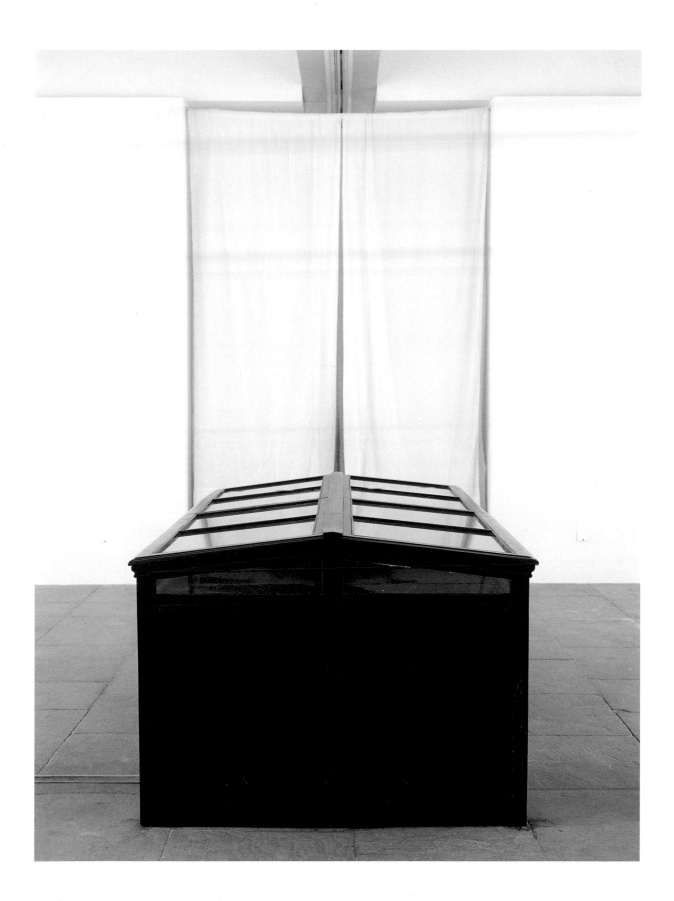

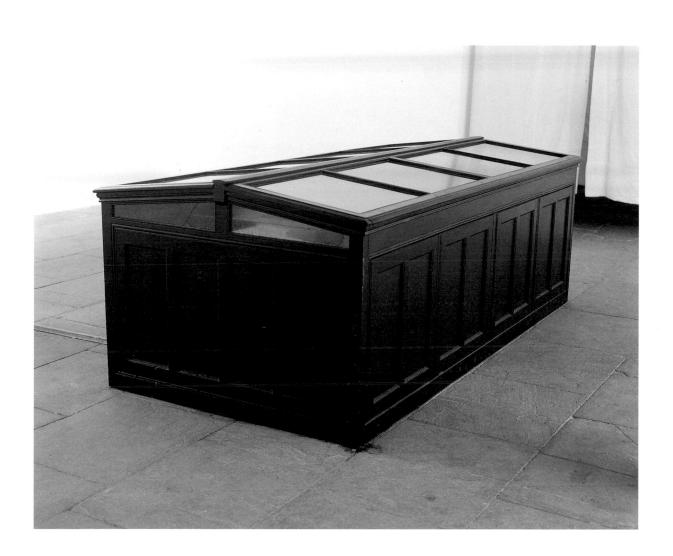

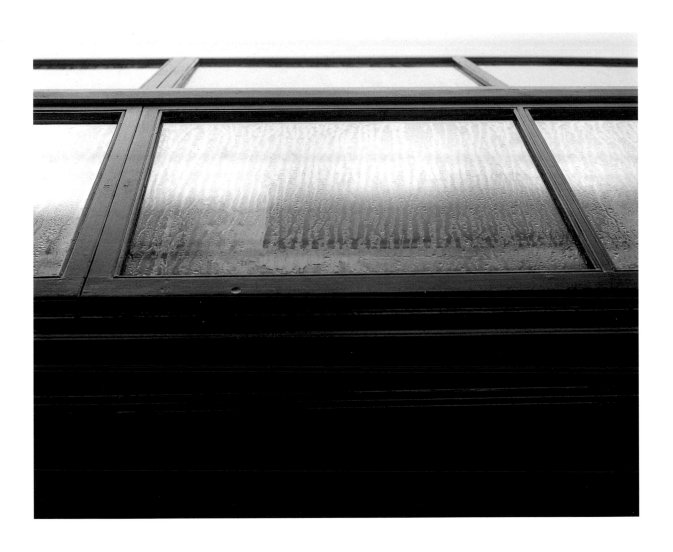

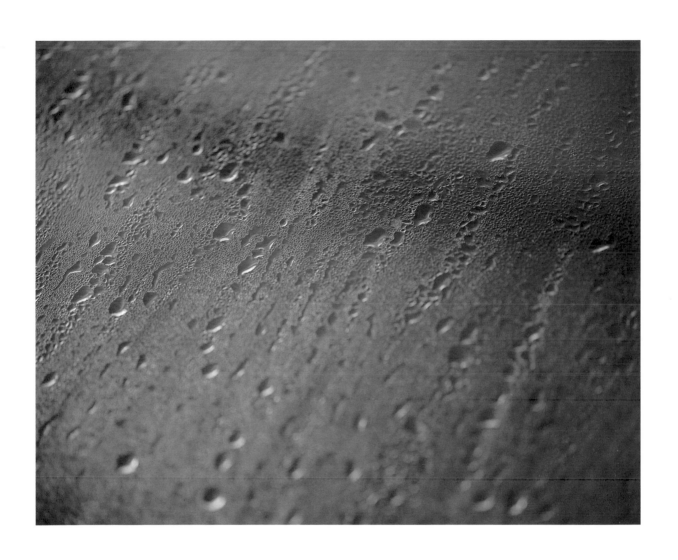

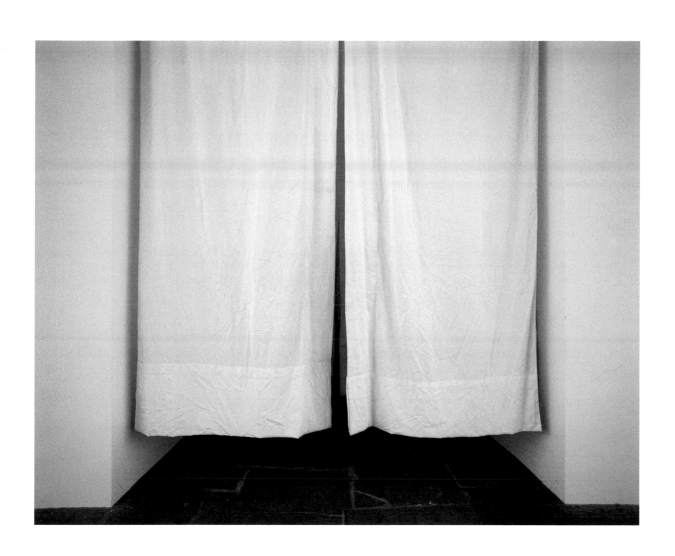

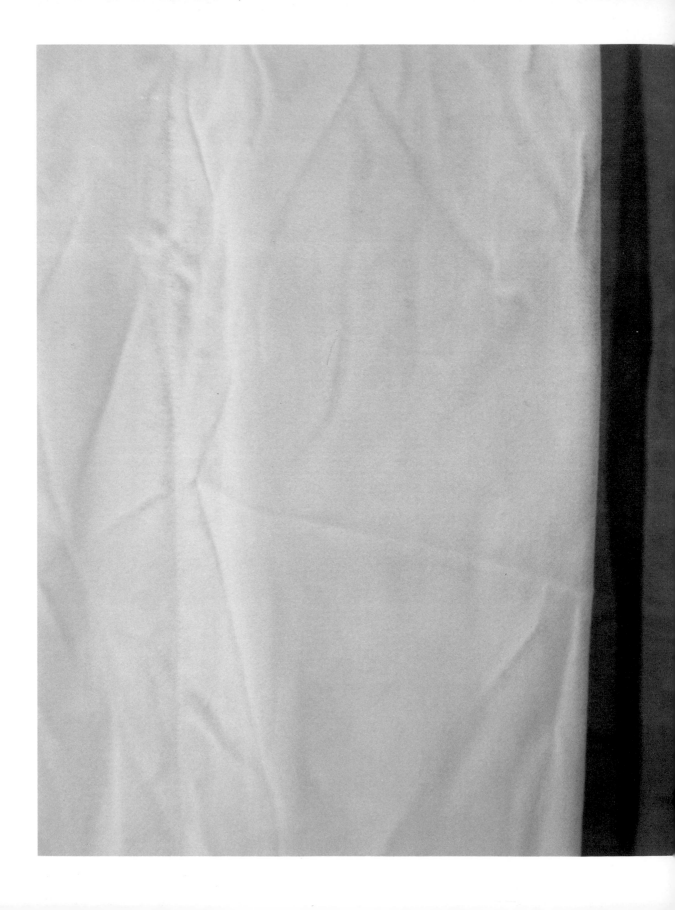

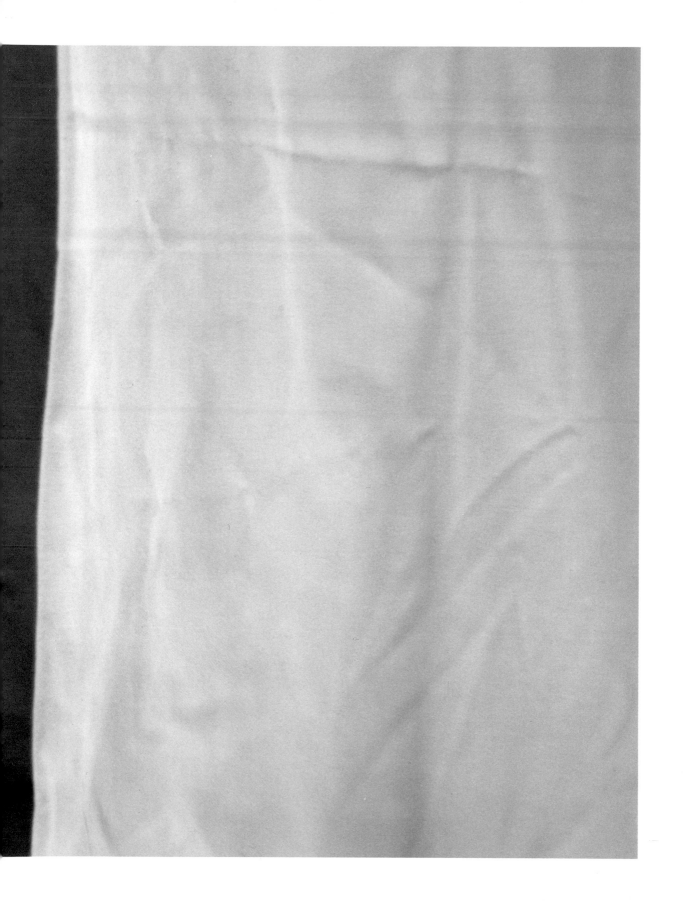

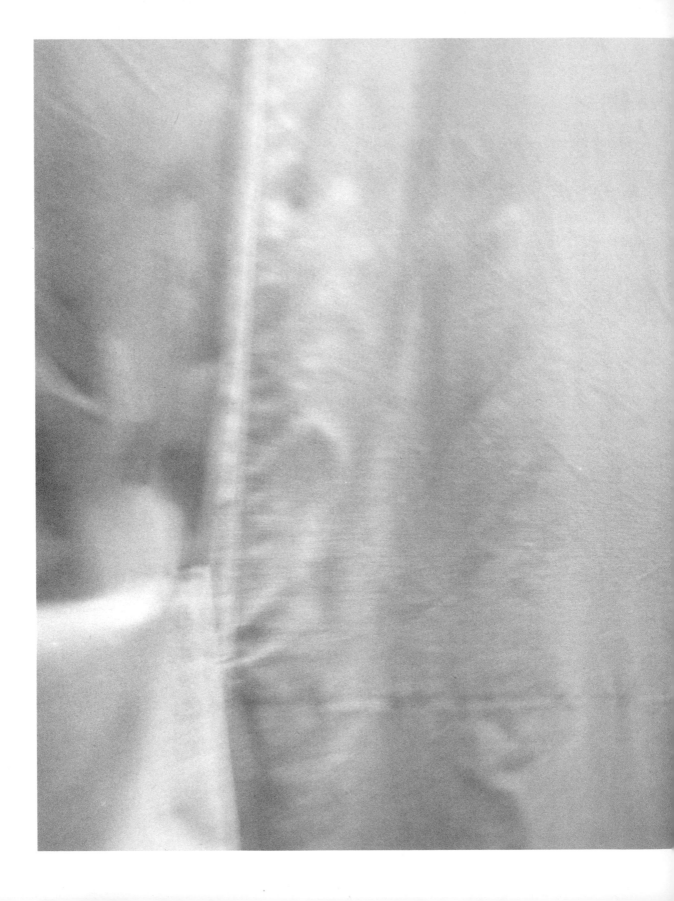

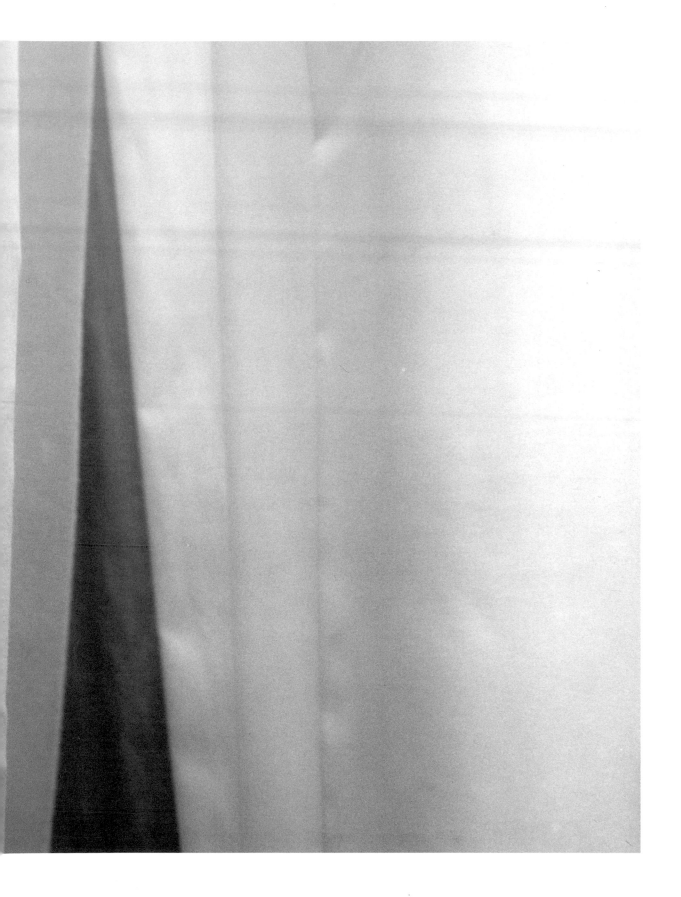

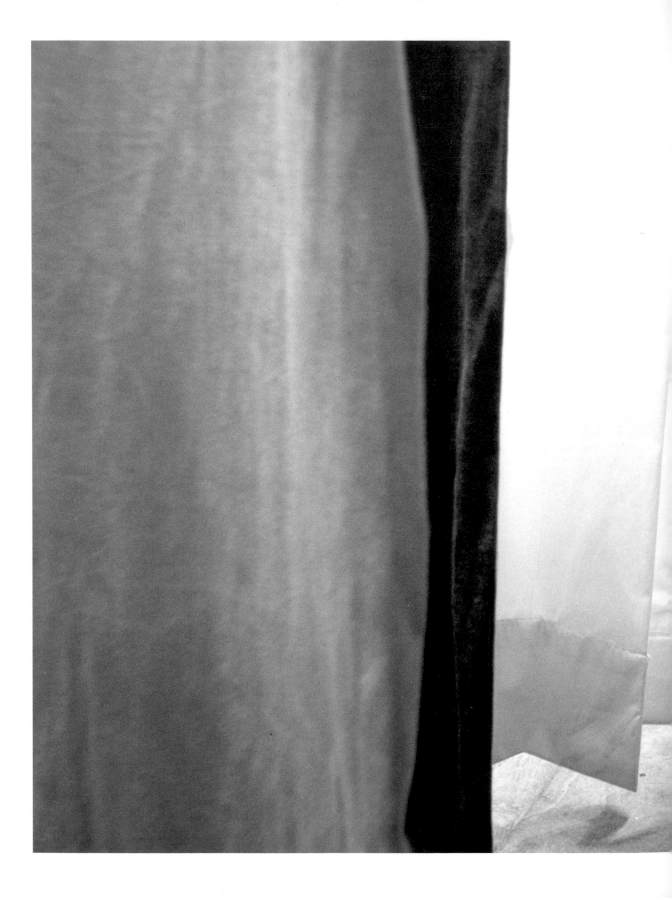

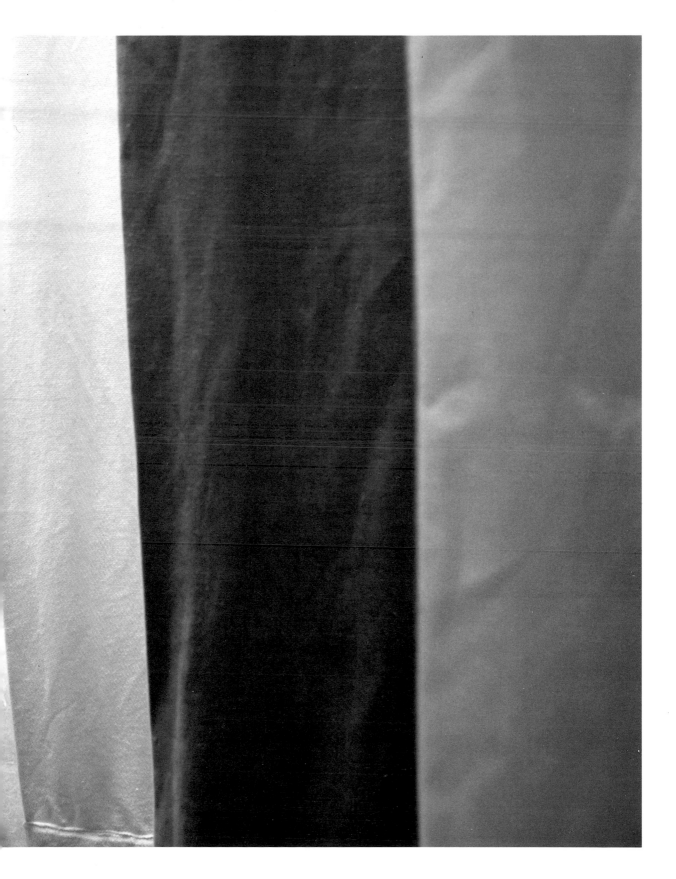

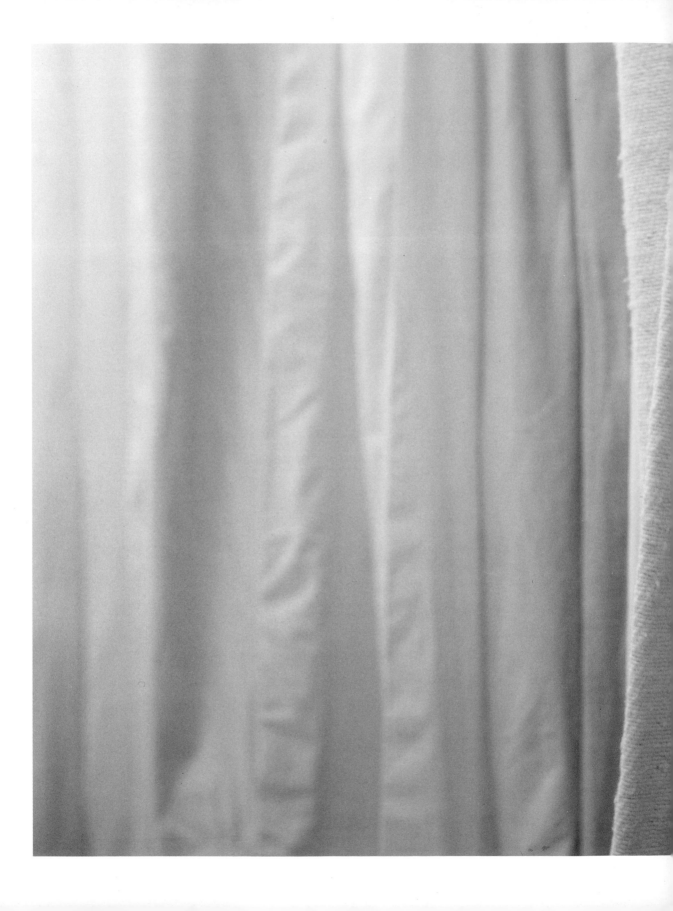

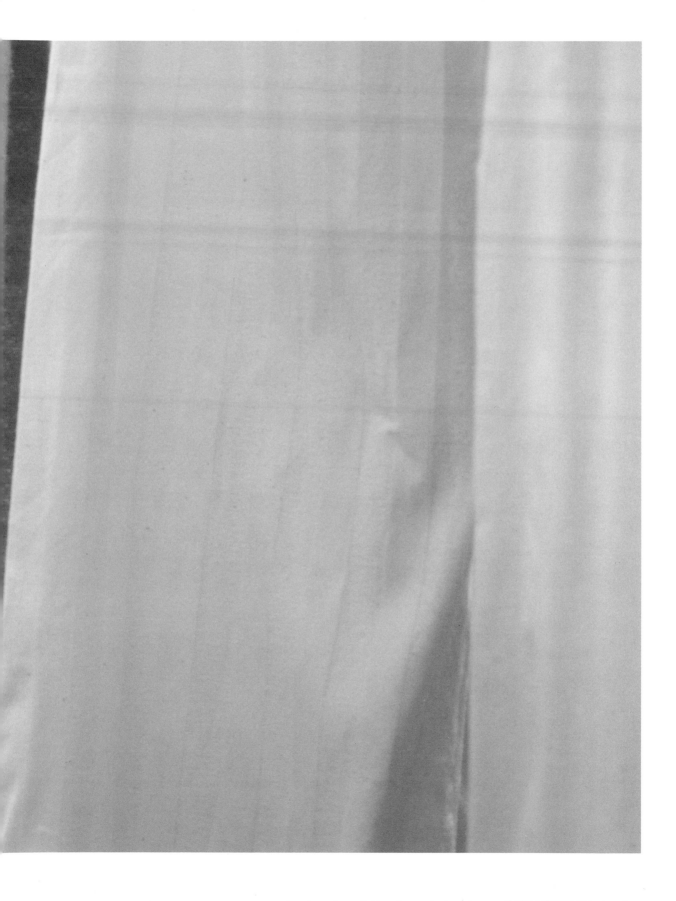

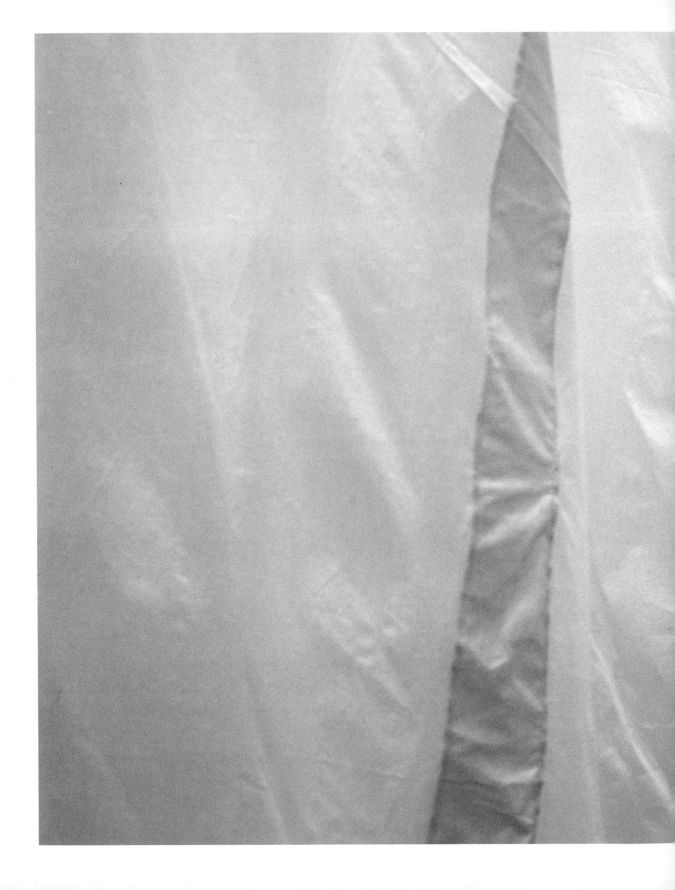

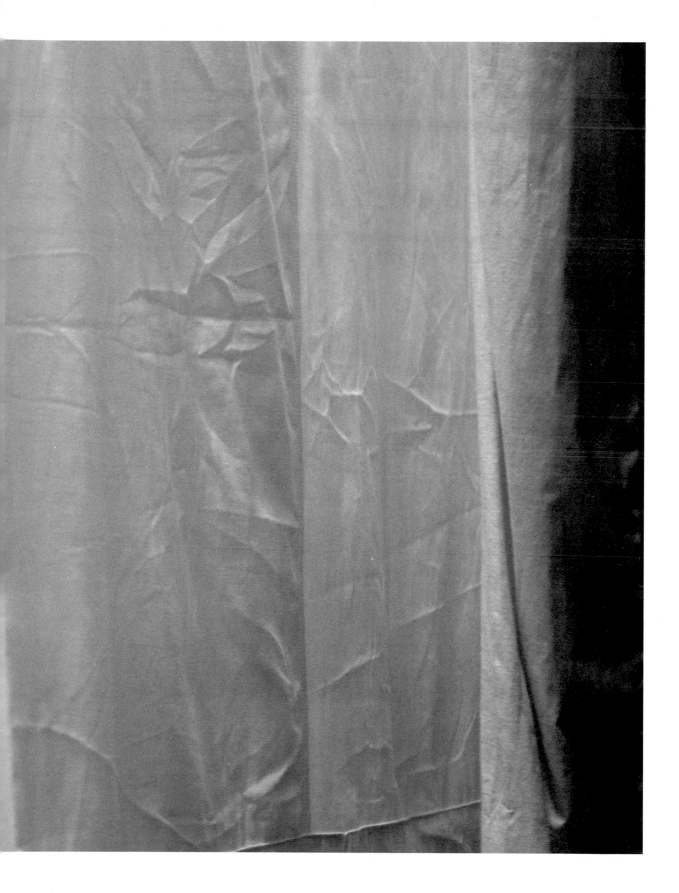

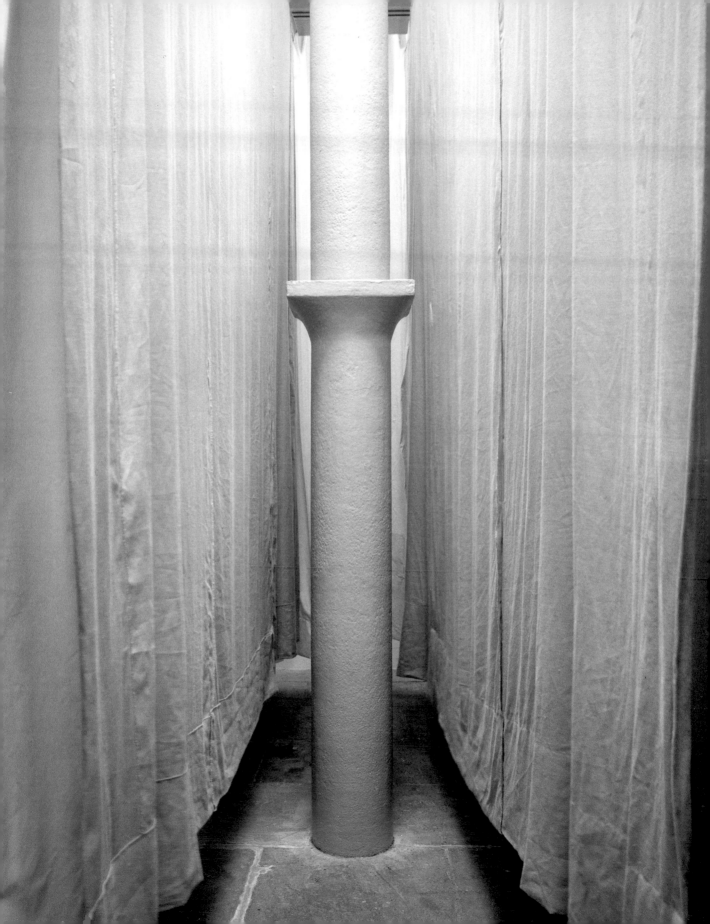

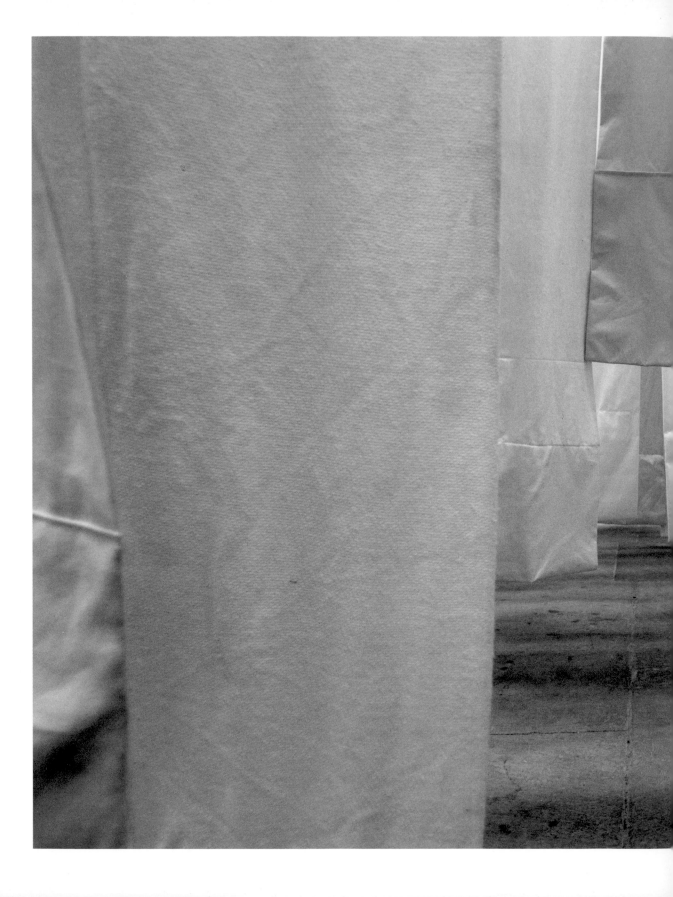

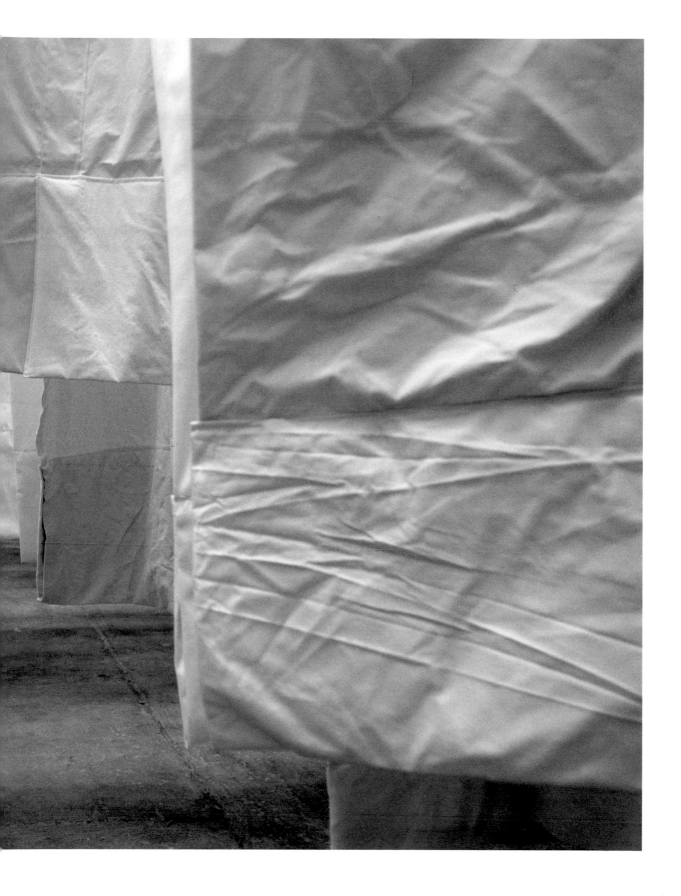

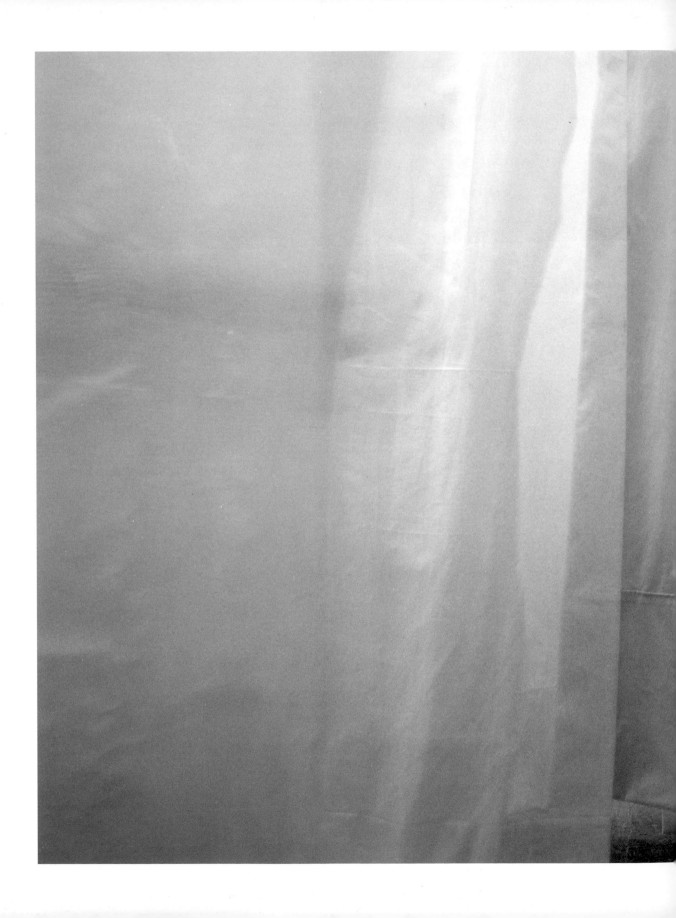

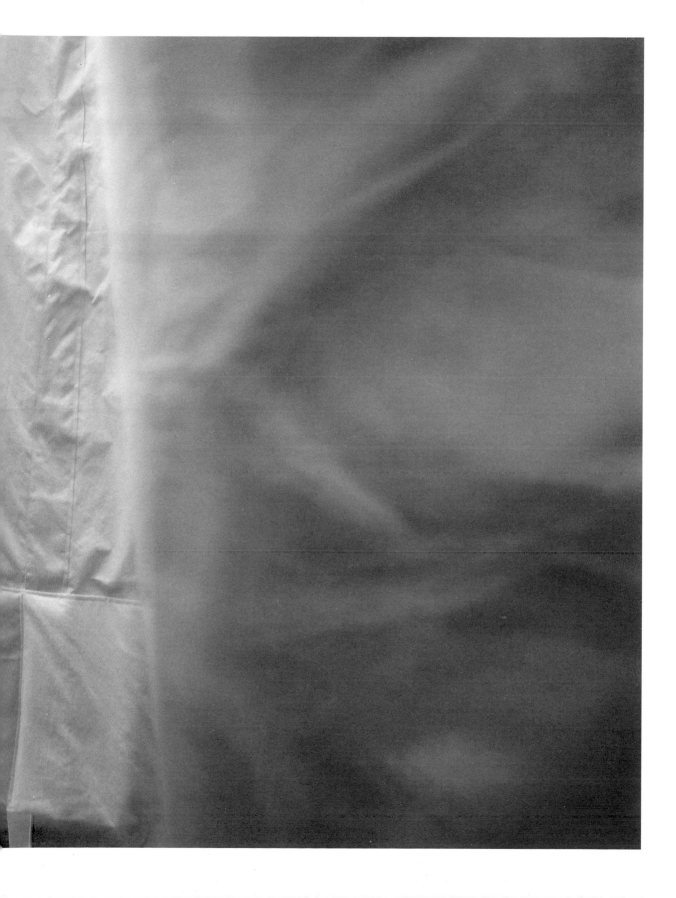

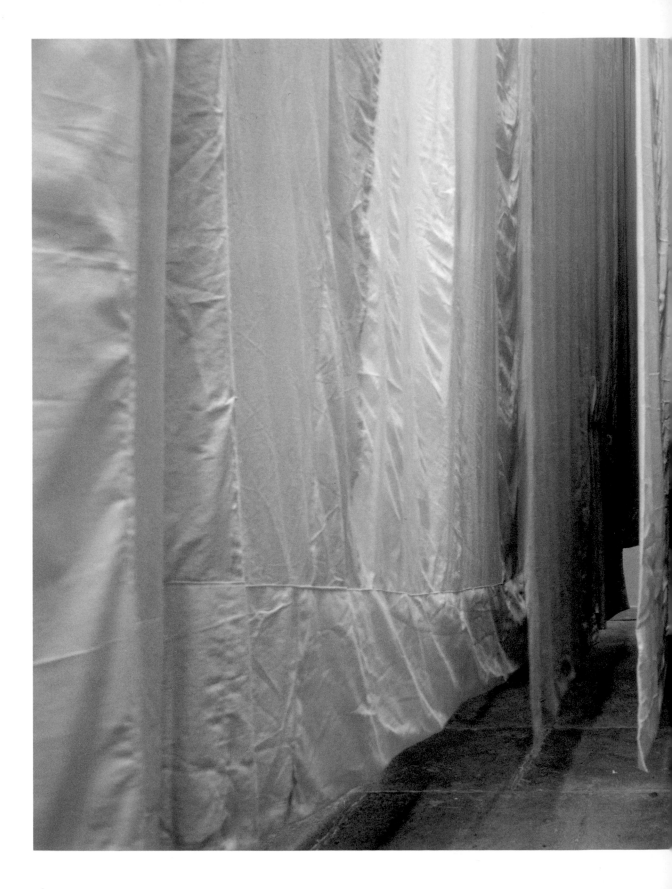

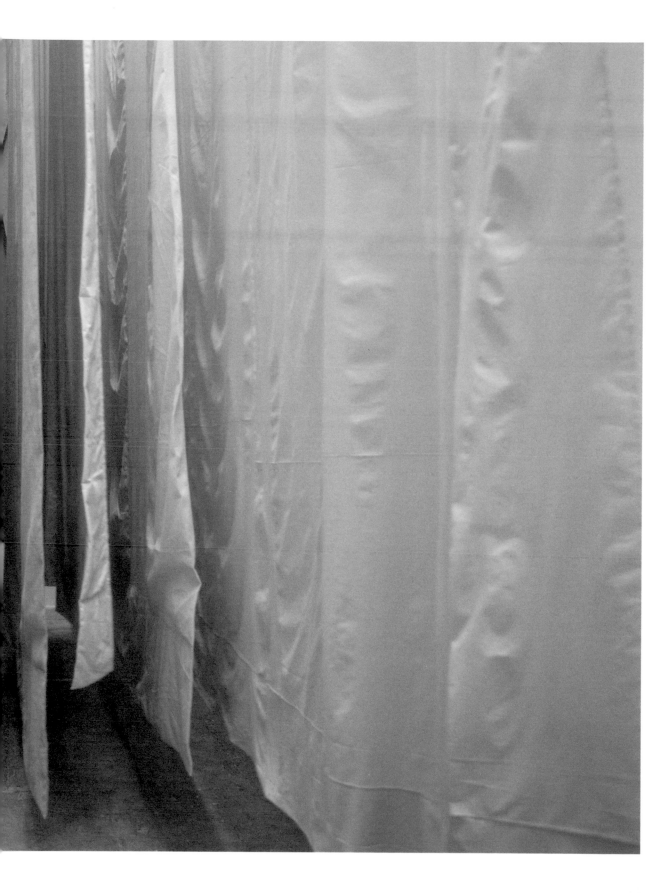

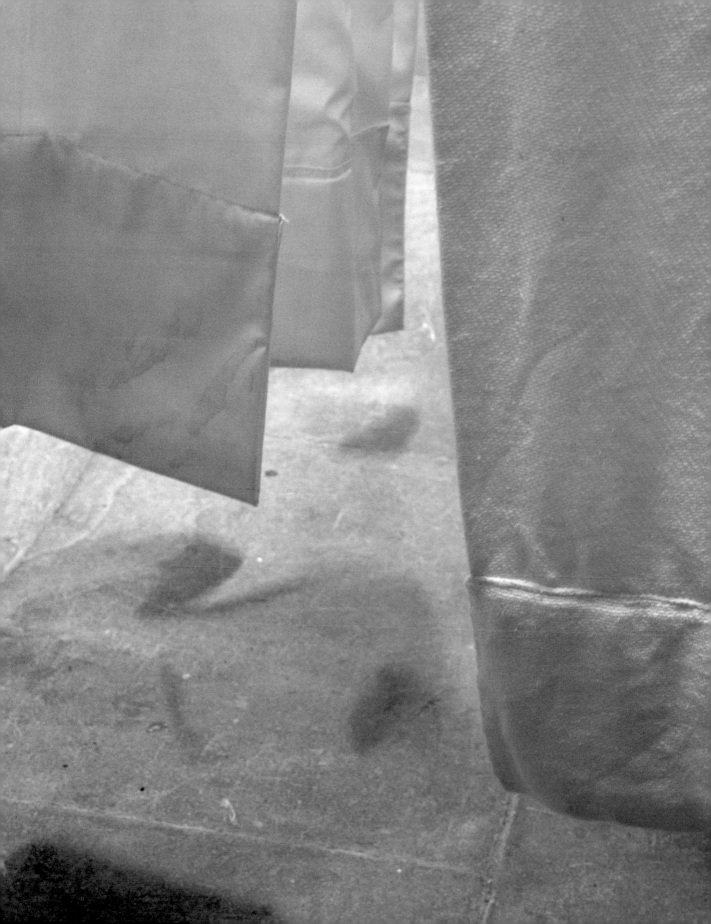

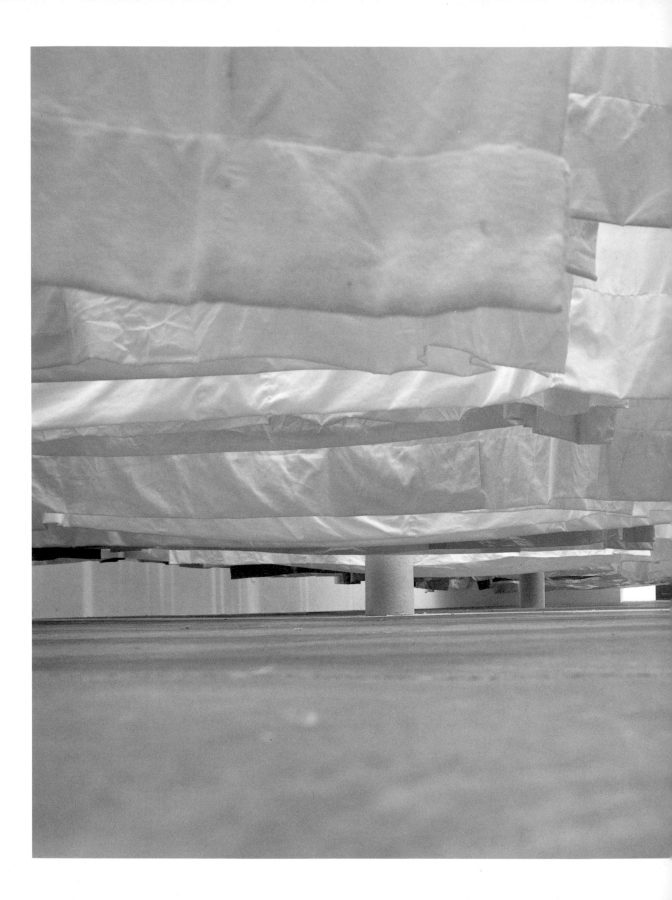

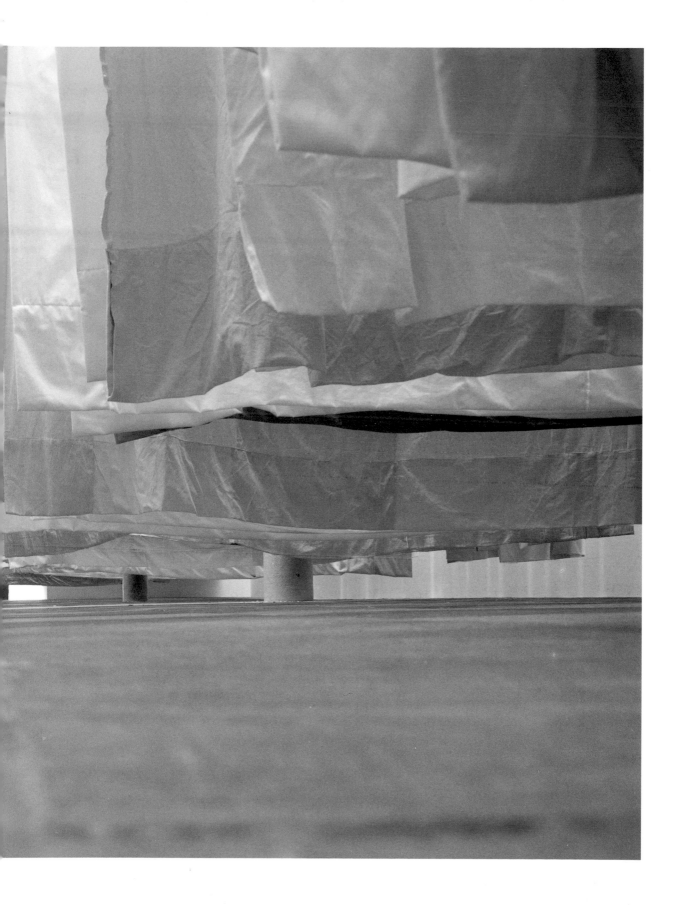

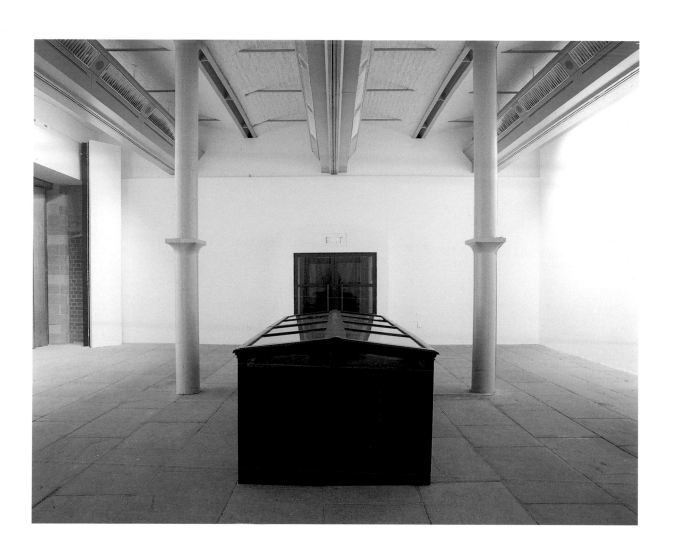

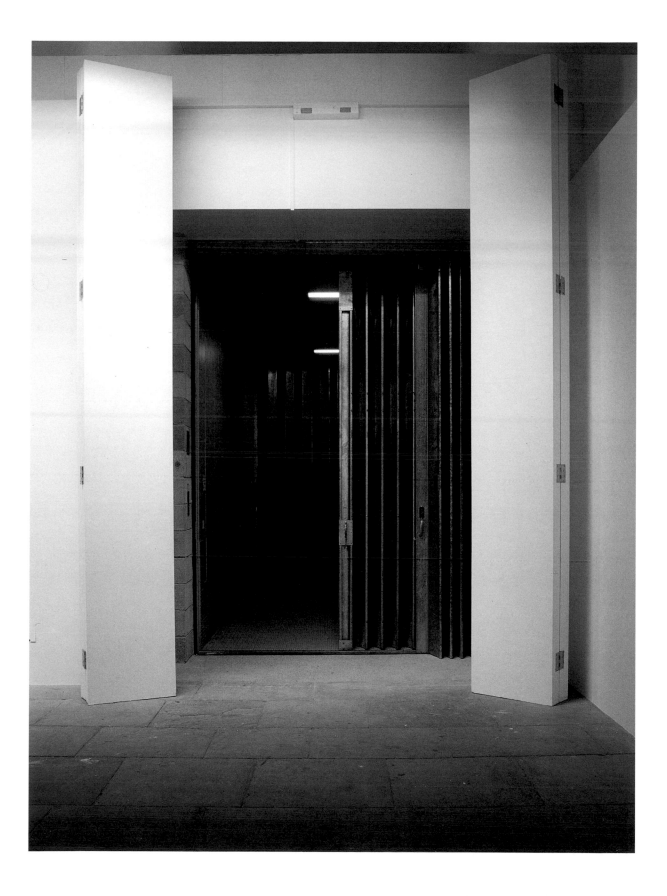

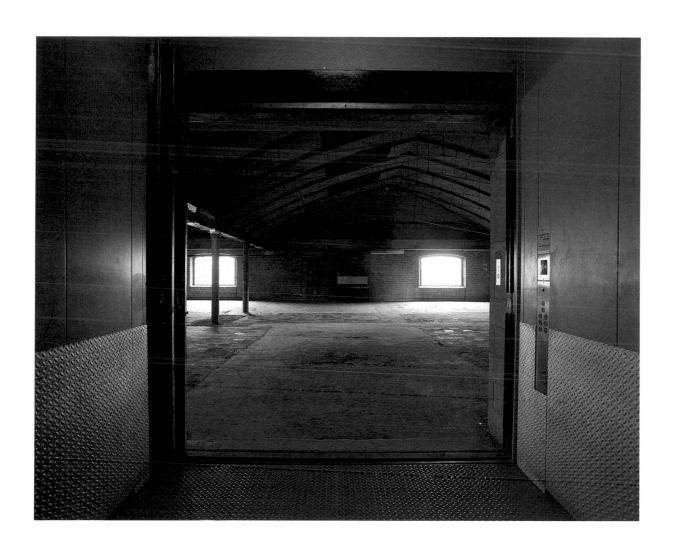

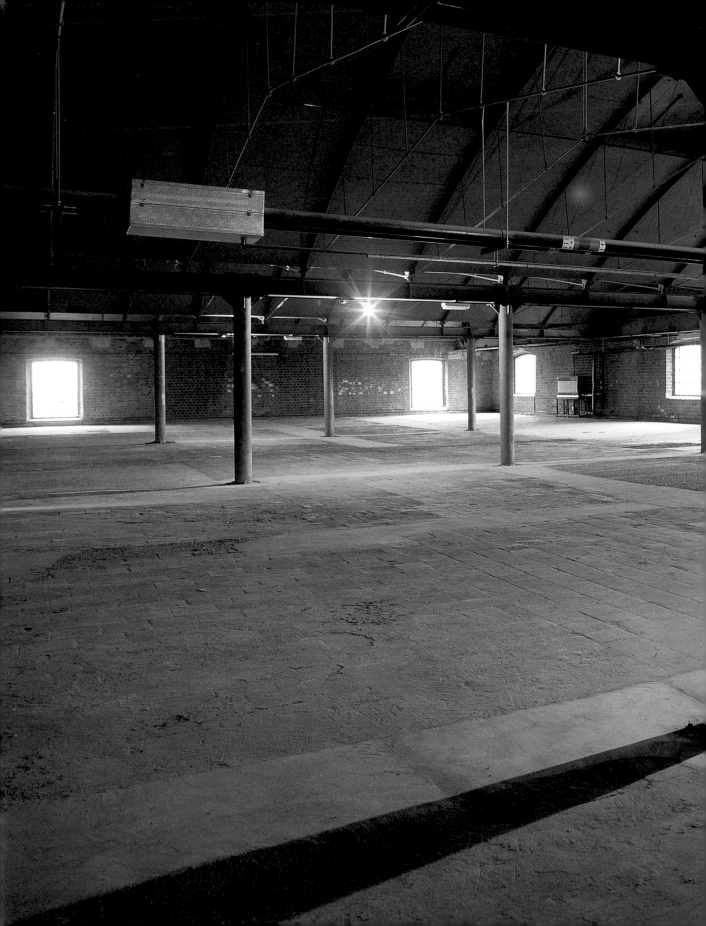

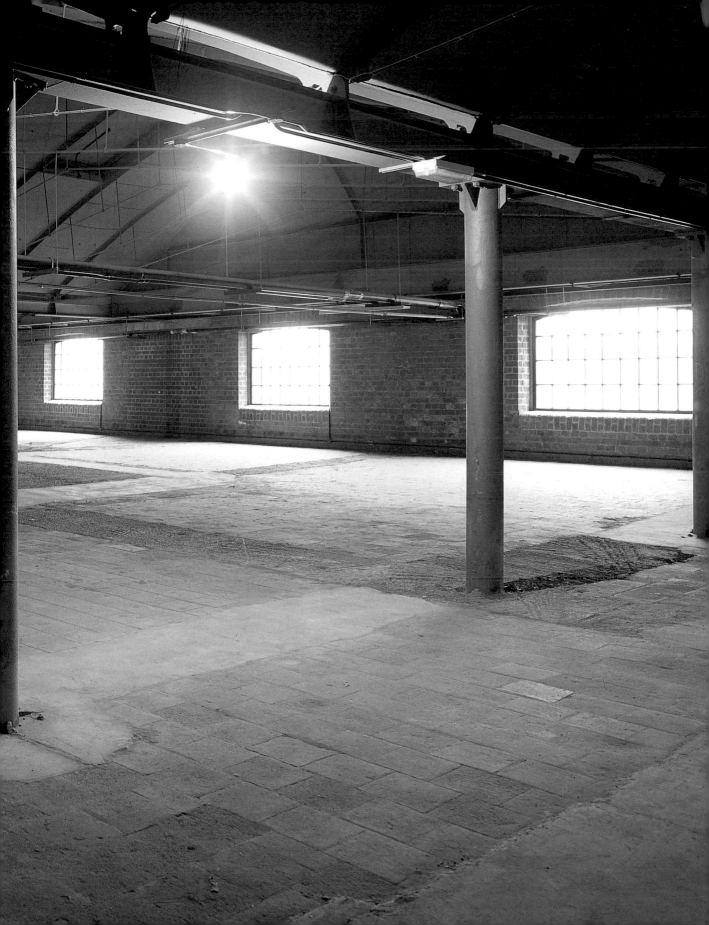

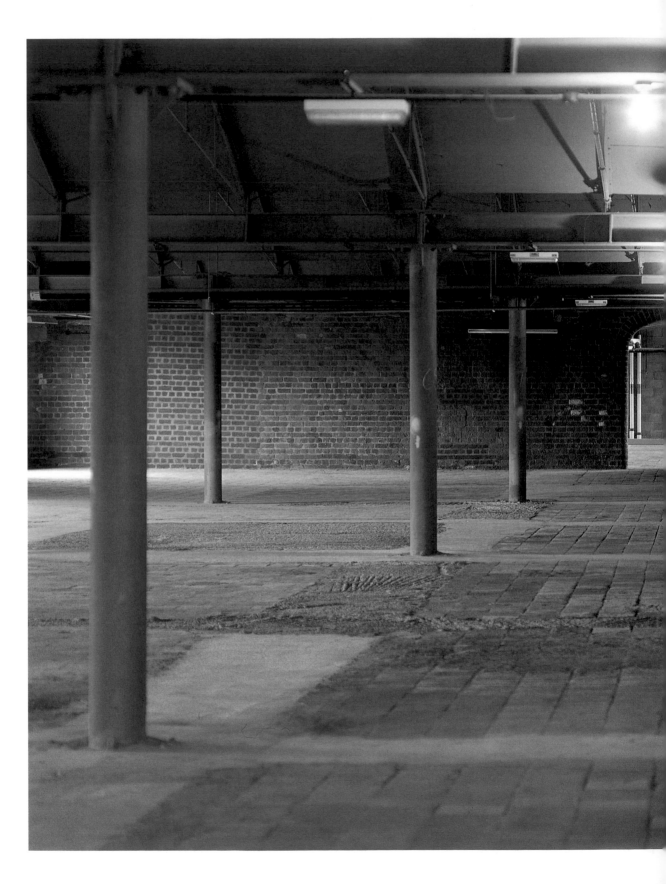

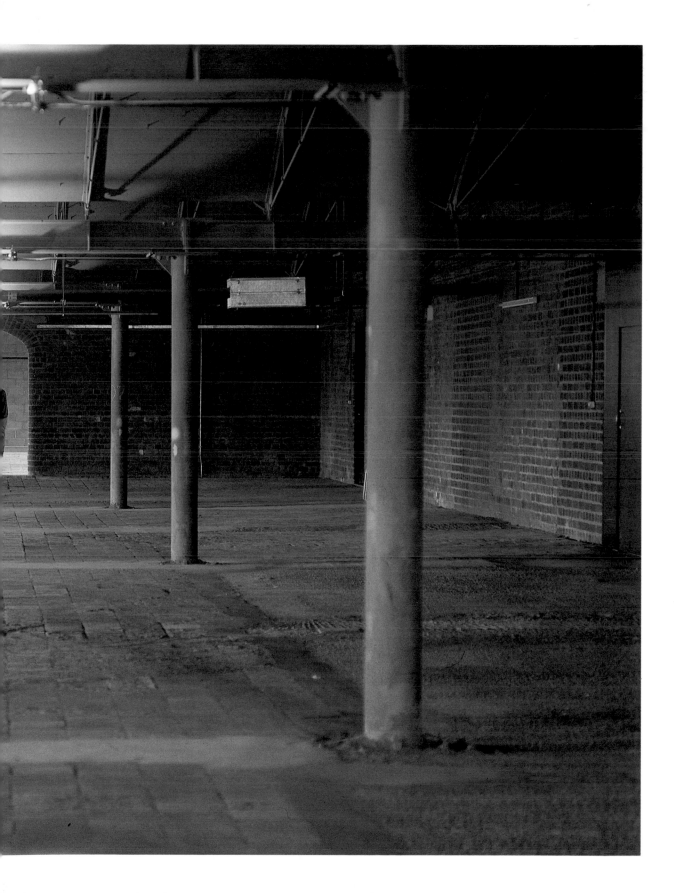

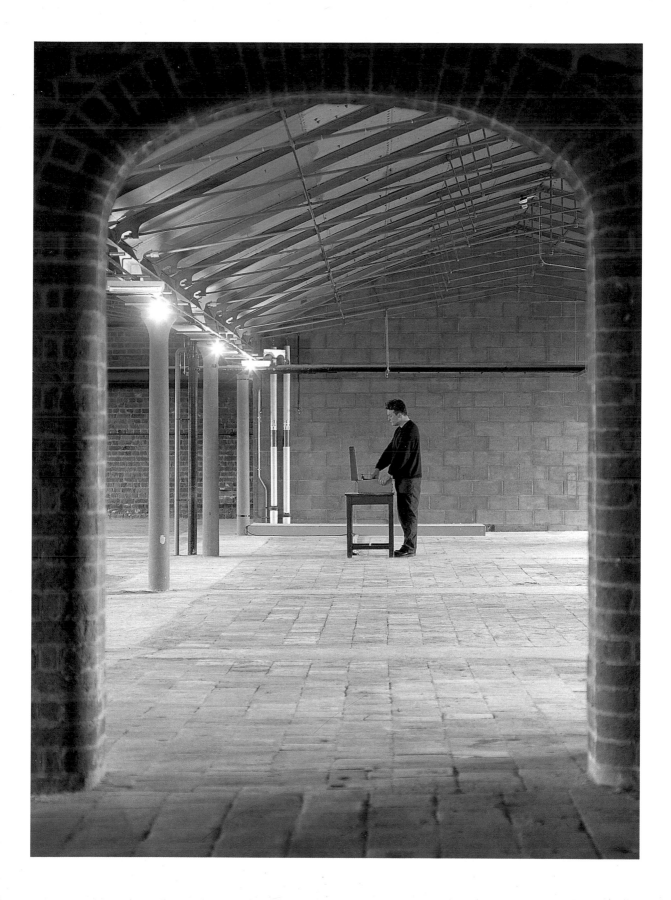

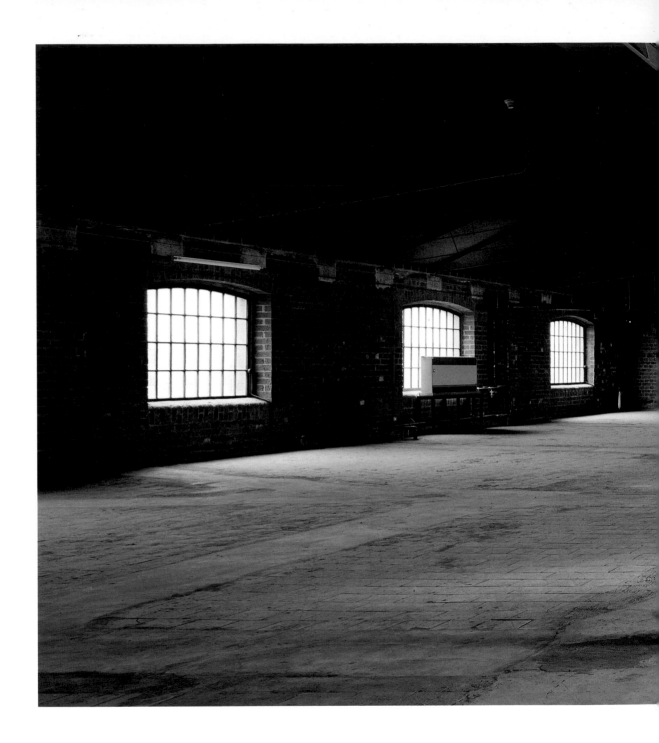

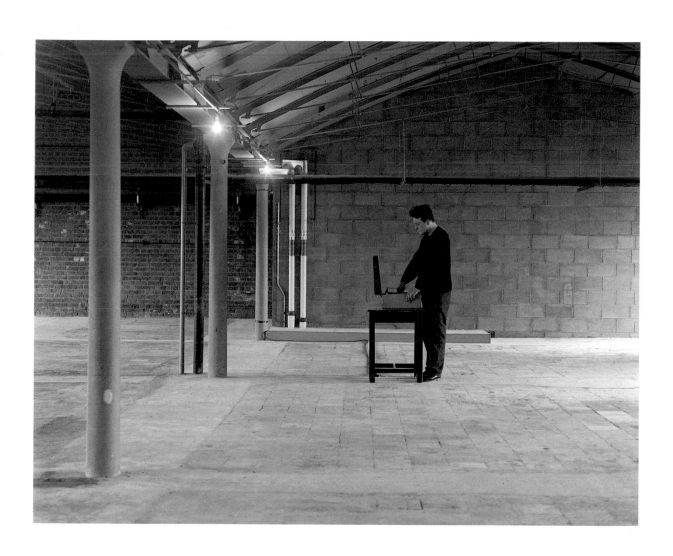

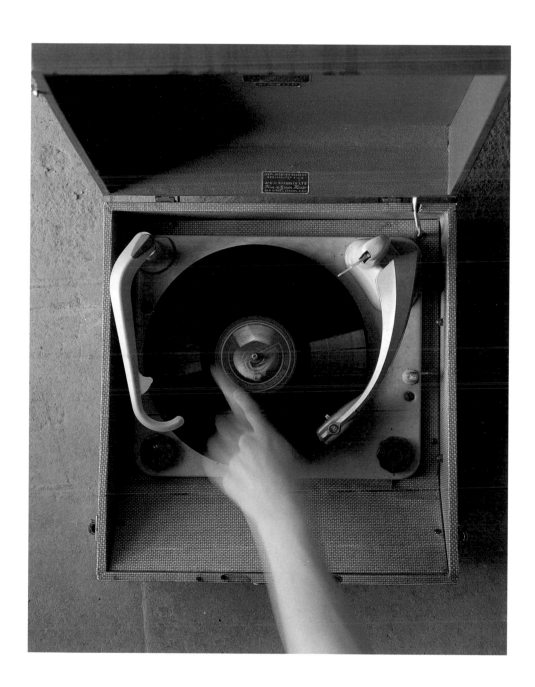

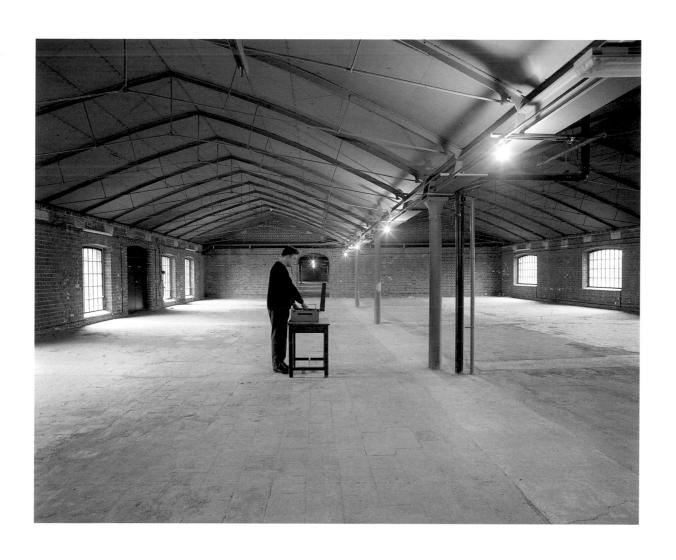

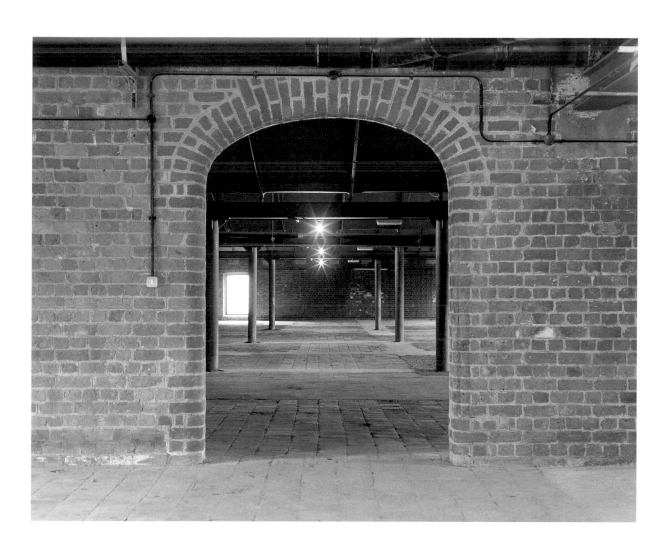

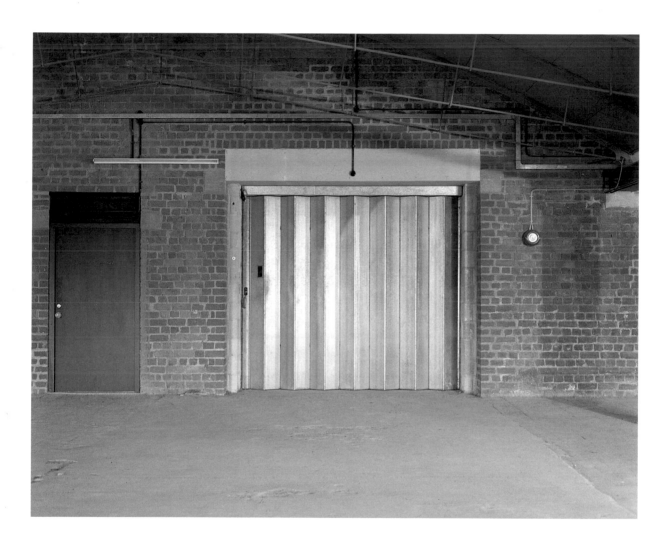

A project of this size and nature needs the help and support of many people. This is a list of those who helped make 'mneme'.

| | |
|---|---|
| Gillian Arnold | Catherine Marcangeli |
| Barry Bentley | John Marlor |
| Lewis Biggs | Sue Martin |
| Julia Bryan | John Massey |
| Lee Champion | Conor McCarron |
| Alfredo Cristiano | Gill McDonough |
| Rachel Dougall | Marie Murtagh |
| Mary Dowrick | Judith Nesbitt |
| Joanne Drury | Tricia Nickson |
| Paul Fletcher | David Parry |
| David Fuller | Wayne Phillips |
| Sarah Gold | Adrian Plant |
| Jean Grant | Robert Rogers |
| Lisa Grimmond | Joanne Russell |
| Nicki Halifax | Elaine Saul |
| Ann Hamilton | Claira Scott-Gray |
| Dawn Hargreaves | Ken Simons |
| Mark Harris | Vicki Skinner |
| Anna Hewitt | Caroline Smith |
| Janet Hodgson | Haf Stephens |
| Gary Holden | Vivienne Stern |
| Trevor James | Vera Vaughan |
| Steve Jones | Caroline Waite |
| Peter Jones | Shulah Walsh |
| Krystofer Kharchinski | Emma Wee |
| Martin Lloyd | Liz Worthington |
| Rebecca des Marais | |

We are also grateful to The Henry Moore Foundation for their generous support.

## Ann Hamilton

Born 1956, Lima, Ohio. Lives in Columbus, Ohio

### Education

1985
Yale School of Art, MFA, Sculpture

1979
University of Kansas, BFA, Textile Design

### Commissioned Projects

1989–90
Mess Hall, Headlands Center for the Arts, Sausalito, California

### Honours

1989
Guggenheim Memorial Fellowship

1991
Represented America at *21st International São Paulo Bienal*, Brazil

1993
MacArthur Fellowship
NEA Visual Art Fellowship

### Individual Exhibitions

\* denotes exhibition catalogue

1985
'reciprocal fascinations', Santa Barbara Contemporary Arts Forum, Santa Barbara

1988
'the capacity of absorption', Temporary Contemporary, Museum of Contemporary Art, Los Angeles

1989
'privation and excesses', Capp Street Project, San Francisco
'between taxonomy and communion', San Diego Museum of Contemporary Art, La Jolla\*

1990
'palimpsest', collaboration with Kathryn Clark, Artemisia Gallery, Chicago, toured to Arton A Galleri, Stockholm

1991
'malediction', Louver Gallery, New York
'parallel lines', *21st International São Paulo Bienal*, Brazil\*
'view', collaboration with Kathryn Clark, *Works*, Hirshhorn Museum and Sculpture Garden, Washington DC\*

1992
'aleph', MIT List Visual Art Center, Cambridge, Massachussetts
'accountings', Henry Art Gallery, University of Washington, Seattle
[untitled], collaboration with David Ireland, Walker Art Center, Minneapolis

1993
'a round', Power Plant, Toronto\*
'tropos', Dia Center for the Arts, New York\*

1994
'mneme', Tate Gallery Liverpool, Liverpool\*
'lineament', Ruth Bloom Gallery, Los Angeles

## Group Exhibitions

### 1984
'suitably positioned' (performance), *Snap Series*, Franklin Furnace, New York

### 1986
'circumventing the tale', *Set in Motion*, Gallery One, San Jose State University, California

'Caught in the Middle' (performance), PS 122, New York, collaboration with Susan Hadley, Bradley Sowash, Bob de Slob

### 1987
'the earth never gets flat', *Elements: Five Installations*, Whitney Museum of American Art at Philip Morris, New York

*Faculty Exhibition* (window installation), Santa Barbara Contemporary Arts Forum, Santa Barbara

'the middle place', *Tangents: Art in Fiber*, Maryland Institute, College of Art, Baltimore; toured to the Oakland Museum, Cleveland Institute of Art

### 1988
'still life', *Home Show: 10 Artists' Installations in 10 Santa Barbara Homes*, Santa Barbara Contemporary Arts Forum, Santa Barbara

'dissections...they said it was an experiment', *Social Spaces*, Artists Space, New York

'dissections...they said it was an experiment', *5 Artists*, Santa Barbara Museum of Art, Santa Barbara

### 1989
'palimpsest', (collaboration with Kathryn Clark), *Strange Attractors, Signs of Chaos*, New Museum of Contemporary Art, New York

### 1990
'dominion', *New Works for New Spaces: Into the Nineties*, Wexner Center for the Visual Arts, Ohio State University, Ohio

'linings', *Awards in the Visual Arts 9*, New Orleans Museum of Art; Southeastern Center for Contemporary Art, Winston-Salem, North Carolina; Arthur M Sackler Museum, Harvard University, Cambridge

### 1991
'offerings', *Carnegie International*, the Carnegie Museum of Art, Pittsburgh*

'indigo blue', *Spoleto Festival*, Charleston, South Carolina

'between taxonomy and communion', *The Savage Garden*, Sala de Exposiciones de la Fundacion Caja de Pensiones, Madrid*

### 1992
*Dirt & Domesticity: Constructions of the Feminine*, Whitney Museum of American Art at Equitable Center, New York

*Habeas Corpus*, Stux Gallery, New York

'passion', *Doubletake: Collective Memory & Current Art*, Hayward Gallery, London*

### 1993
'attendance', *Sonsbeek 93*, Arnhem*

*Future Perfect*, Heiligenkreuzerhof, Vienna

*readymade identities*, The Museum of Modern Art, New York

'aleph', *Doubletake: Kollektives Geächtnis & Heutige Kunst*, Kunsthalle Wien, Vienna

**Selected Bibliography**

1987

Mary Jane Jacob, *Tangents: Art in Fiber*, Maryland Institute, College of Art, Baltimore, 1987 *

1988

Kenneth Baker, *5 Artists*, Santa Barbara Museum of Art, Santa Barbara, 1988 *

Kenneth Baker, 'Art Comes to Dinner in Santa Barbara', *San Francisco Chronicle*, 21 September 1988

Michael Brenson, 'A Transient Art Form With Staying Power', *New York Times*, 10 January 1988, Section 2, pp33,36

Eleanor Heartney, 'Elements: Five Installations', *Artnews*, April 1988, p156

Eleanor Heartney, 'Strong Debuts', *Contemporeana*, July–August 1988, pp110–112

Joan Hugo, 'Domestic Allegories', *Artweek*, 1 October 1988

Patricia C Phillips, 'Social Spaces', *Artforum*, May 1988, p148

Valerie Smith, *Social Spaces*, Artists Space, New York, 1988

1989

Kenneth Baker, 'Pennies from Heaven in Sea of Honey', *San Francisco Chronicle*, 25 March 1989

Peter Frank, 'Better Vision Through Spectacles', *LA Weekly*, January 1989, pp13–19

Suvan Geer, 'The Cerebral, The Sensory, The Spiritual', *Artweek*, 28 January 1989, p1

Ann Hamilton, 'A text for privation and excesses', *Artspace*, November–December 1989, p59

Joan Hugo, 'Ann Hamilton: Cocoons of Metaphors', *Artspace*, November–December 1989, pp54–8

Michael Kimmelman, 'Searching for Some Order in a Show Based on Chaos', *New York Times*, 15 September 1989

Kay Larson, 'Coming Round Again', *New York Magazine*, 23 October 1989, pp149–150

Gay Morris, 'Ann Hamilton at Capp Street Project',
*Art in America*, October 1989, pp221,3

David Pagel, 'Ann Hamilton', *Arts Magazine*, March 1989, p76

Rebecca Solnit, 'Ann Hamilton: privation and excesses', *Artweek*, 8 April 1989, p5

Buzz Spector, 'A Profusion of Substance', *Artforum*, October 1989 pp120–8

Laura Trippi, *Strange Attractors: Signs of Chaos*, New Museum of Contemporary Art, New York, 1989 *

1990

Kenneth Baker, 'Ann Hamilton: San Diego Museum of Contemporary Art', *Artforum*, October 1990

John Howell, 'Alchemy of Edges', *Elle*, [American edition], April 1990, p228

David Pagel, 'Vexed Sex', *Artissues*, no 9, February 1990, pp11–16

David Pagel, 'Still Life: The Tableaux of Ann Hamilton', *Arts Magazine*, May 1990, pp56–61

David Pagel, 'Ann Hamilton', *Lapiz: International Art Magazine*, June 1990, p87

Buzz Spector, 'A Profusion of Substance', *Artforum International*, October 1990, pp120–8

1991

Kenneth Baker, 'Art Trek: Where No Critic Can See It Whole', *San Francisco Chronicle*, 1991, p37

Jose Luis Brea, 'The Savage Garden: The Nature of Installation', *Flash Art*, vol xxiv, no 158, May/June 1991, p129

Michael Brenson, 'Visual Arts Join Spoleto Festival USA', *New York Times*, 27 May 1991, pp11,14

Dan Cameron, 'The Savage Garden: Landscape as Metaphor in Recent American Installations', *El Jardin Salvaje*, Fundacion Caja de Pensiones, Madrid, 1991 *

Bradford R Collins, 'Report From Charleston: History Lessons', *Art in America*, November 1991, pp64–71

Laura Cottingham, 'Ann Hamilton: A Sense of Imposition', *Parkett*, vol 30, 1991, pp130–4

Arthur C Danto, 'Art: Spoleto Festival USA', *The Nation*, 29 July – 5 August 1991, pp168–172

Lynn Gumpert, 'Cumulus From America', *Parkett*, no 29, 1991, pp163–6

Ann Hamilton and Kathryn Clark, 'view: ann hamilton/kathryn clark', *Works*, Hirshhorn Museum and Sculpture Garden, Washington, 1991

Joan Hugo, *Ann Hamilton: 21st Bienal International de São Paulo*, 1991, Seattle, 1991

Michael Kimmelman, 'At Carnegie 1991, Sincerity Edges Out Irony', *New York Times*, 27 October 1991

Sarah Rogers-Lafferty, 'New Works for New Spaces into the Nineties', *Breakthroughs: Avant-Garde Artists in Europe and America, 1950–1990*, Wexner Center for the Arts, Ohio State University, 1991 *

Margo Schermeta, 'Ann Hamilton: Installations of Opulence and Order', *Fiberarts*, vol 18, no 2, 1991, pp30–4

Susan Stewart, *Ann Hamilton*, San Diego Museum of Contemporary Art, La Jolla, 1991 *

1992

'Ann Hamilton Installations', *Harvard Architecture Review 8*, 1992, ppii,vi,192,200

Kenneth Baker, 'The 1991 Carnegie International: Inwardness and a Hunger for Interchange', *Artspace*, January–April 1992, pp81–5

Debra Bricker Balken, 'Ann Hamilton at Louver', *Art in America*, March 1992, pp121–2

Chris Bruce, Rebecca Solnit, Buzz Spector, *Ann Hamilton*, Henry Art Gallery, University of Washington, Seattle, 1992 *

Dan Cameron, 'Art and Politics: The Intricate Balance', *Art & Auction*, 1992, pp76–80

Lynne Cooke and Mark Francis, *Carnegie International 1991*, The Carnegie Museum of Art, Pittsburgh, 1992 *

Lynne Cooke, Bice Curiger and Greg Hilty, *Doubletake: Collective Memory & Current Art*, The Hayward Gallery, London, 1992 *

Gretchen Faust, 'Ann Hamilton, Louver', *Flash Art*, March/April 1992

Bruce Ferguson, 'In the Realm of the Senses', *Mirabella*, April 1992, pp62–4

Faye Hirsch, 'Ann Hamilton', *Arts*, March 1992, p67

Mary Jane Jacob, *Places with a Past: New Site-Specific Art in Charleston*, Charleston, South Carolina, Spoleto Festival USA, 1992 *

Amy Jinkner-Lloyd, 'Musing on Museology', *Art in America*, June 1992, pp44–51

Elaine A King, 'Carnegie International 1991, Mattress Factory, Pittsburgh', *Sculpture*, May–June 1992, p95

Kay Larson, *New York Magazine*, 13 January 1992, p66

Edward Leffingwell, 'The Bienal Adrift', *Art in America*, March 1992, pp83–7,135

Stuart Morgan, 'Stuart Morgan Reviews Doubletake', *Frieze*, May 1992, pp7–11

Lyn Smallwood, 'Ann Hamilton: Natural Histories', *Artnews*, April 1992, pp82–3

Amy Sparks, 'Ann Hamilton', *dialogue*, May–June 1992, pp13–15

1993

Dan Cameron, 'Future Perfect, or, Notes on the Limits of Indifference', *Future Perfect*, Heiligenkreuzerhof, Vienna, 1993 *

Faye Hirsch, 'Art at the Limit: Ann Hamilton's Recent Installations', *Sculpture*, July–August 1993, pp32–9

Janet Koplos, 'Parachuting into Arnhem', *Art in America*, October 1993, pp52–7

1994

Neville Wakefield, 'Presence of Mind', *Vogue* [American edition], March, 1994, pp374–9, 432–4

Judith Nesbitt, Neville Wakefield, *Ann Hamilton: mneme*, Tate Gallery Liverpool, Liverpool, 1994*

Neville Wakefield is a writer living in New York

Judith Nesbitt is Exhibitions Curator, Tate Gallery Liverpool

The Trustees and Director of the Tate Gallery are indebted to the following for their generous support:

American Airlines
AIB Bank
Art Services Management
Arts Council of Great Britain
Australian Bicentennial Authority
BMP DDB Needham
Barclays Bank Plc
The Baring Foundation
BASF
Beck's
David and Ruth Behrend Trust
The Blankstone Charitable Trust
The Boston Consulting Group
Ivor Braka Ltd
British Alcan Aluminium Plc
British Telecom
Business Sponsorship Incentive Scheme
Calouste Gulbenkian Foundation
Canadian High Commission, London
    and The Government of Canada
Mr and Mrs Henry Cotton
The Cultural Relations Committee
Department of Foreign Affairs, Ireland
English Estates
The Foundation for Sport and the Arts
Girobank
Goethe Institut, Manchester
Granada Business Services
Granada Television
The Henry Moore Foundation
The Henry Moore Sculpture Trust
IBM United Kingdom Trust
Ibstock Building Products Limited
ICI Chemicals and Polymers Ltd

The Laura Ashley Foundation
The Littlewoods Organisation
McCollister's Moving and Storage Inc
Manweb plc
Martinspeed Limited
Merseyside Development Corporation
Merseyside Task Force
Mobil Oil Company
Momart Plc
National Art Collections Fund
National Westminster Bank Plc
North West Water Group PLC
NSK Bearings Europe Ltd
Patrons of New Art, Friends of the
    Tate Gallery
Pentagram Design Ltd
Pioneer High Fidelity (G.B.) Ltd
J Ritblat Esq
David M Robinson Jewellery
Samsung Electronics
Save and Prosper
Seok-Nam Foundation
Stanley Thomas Johnson Foundation
Tate Gallery Foundation
Tate Gallery Liverpool Supporters
Tate Gallery Publications
Unilever Plc
VideoLogic Ltd
Visiting Arts
Volkswagen

This book is published to document 'mneme', an exhibition by Ann Hamilton
at Tate Gallery Liverpool, 21 January – 6 March 1994

ISBN 1-85437-138-X

Prepared by Tate Gallery Liverpool and published by
Tate Gallery Publications, Millbank, London SW1P 4RG

Edited by Judith Nesbitt
Prepared by Jemima Pyne and Helen Ruscoe
Designed by Herman Lelie
Typeset by Goodfellow and Egan, Cambridge

Produced in the EU by Oktagon, Stuttgart

Copyright Tate Gallery Liverpool and the authors

'St Jerome in his Study' is reproduced by
kind permission of the Trustees of
the National Gallery, London

All photographs of 'mneme' are by Hugo Glendinning

All works by Ann Hamilton are courtesy of Sean Kelly, New York